IMAGES
of America

SEATTLE'S
GREEN LAKE

IMAGES
of America

SEATTLE'S
GREEN LAKE

Brittany Wright

ARCADIA
PUBLISHING

Published by Arcadia Publishing
Charleston SC, Chicago IL, Portsmouth NH, San Francisco CA

Printed in the United States of America

Library of Congress Catalog Card Number: 2006926070

For all general information contact Arcadia Publishing at:
Telephone 843-853-2070
Fax 843-853-0044
E-mail sales@arcadiapublishing.com
For customer service and orders:
Toll-Free 1-888-313-2665

Visit us on the Internet at www.arcadiapublishing.com

CONTENTS

ACKNOWLEDGMENTS

Many of the images in this book appear courtesy of the Museum of History and Industry, the Green Lake Library, the Seattle Municipal Archives, and the University of Washington Libraries.

The author would like to thank the Green Lake Library, Bill Ibsen, Carolyn Marr, the Nordstrand family, and Clinton White for their assistance and contributions.

Thanks also go to the author's family, editor Julie Albright, Mark Christianson, Sarah Northmore, Anne Bippy Owens, and everyone at Epilogue Books for their personal support.

INTRODUCTION

About 14,000 years ago, the massive ice sheets of the Vashon Glacier rolled south from Canada. Rising to a thickness of roughly 3,000 feet, they advanced across most of what is now Washington State, rearranging the land into a unique variety of salient hills and basins. When the glacier receded to reveal these striking new landforms, numerous catchments had been carved into the landscape, characterizing one of the most unusually alluring geographies in the United States.

In September of 1855, a man by the name of David Phillips, on behalf of the U.S. Surveyor General, arrived at the edge of a body of water a mile wide, surrounded by a forest of Douglas fir and protected by soft hills. Struck by the profuse algae blooms coloring the waters, he named it Lake Green. Fourteen years later, Erhart "Green Lake John" Siegfried claimed 130 acres of land there and built the first pioneer cabin known to exist on its shores. One by one, then in droves, settlers and investors fell under the rich magnetism of the lake. While desiring to make it the centerpiece of urban and commercial development, they had a profound respect and concern for the lake as a natural landmark from the very beginning. As William D. Wood wrote for the *Green Lake News* in 1903, "Its shores and waters can always be kept free from the obstructions and dangers of commercial use." Wood purchased Siegfried's holdings in 1887 and quickly became one of Seattle's most prominent individuals of the day, holding many influential positions, including probate judge of King County and then mayor, as well as partner in both the Green Lake Electric Railway and the Seattle and Yukon Trading Company. Working closely with a superior group of other visionary leaders, such as Guy Phinney, Corliss Kilbourne, Judge Frederick A. McDonald, and John Olmsted, Wood planned rigorously to protect the lake as he helped to develop its neighborhood, ensuring a foundation for a place, free and accessible to everyone, that would attract visitors from all over to this vibrant heart of a community.

The varied architecture throughout the Green Lake neighborhood conjures an almost indescribable raptness for the beholder. For newer residents, it evokes a nostalgia for a time that can only be experienced second hand. For others, there seems to be a sort of comfort that those times have not yet disappeared entirely—a reminder of what the lake has meant to them. Like any other neighborhood, Green Lake has its stories, as unique as each of the old houses still overlooking the water. But unlike any other neighborhood, these stories crisscross over the surface of the lake, like the ice-skaters that clamored to catch each other's outstretched hands gliding by, many winters ago.

A multitude of laborious efforts have been exerted since Green Lake's founding to halt its decay by treating its waters and dredging its sediments. It is no small wonder that, because of a community that truly believed this feature was meant for a brighter future, it still exists today with all it has to offer. Each of its abundant attractions and facilities, from the Small Crafts Center and Evans Pool, to Duck Island and even the shoreline itself, has a tale to tell involving the hard work, inspiration, and design of multiple individuals. Many of its original landmarks did not survive, and their memories fade perilously the longer they remain unpreserved. Those that

do survive are equally as interesting, their histories being a mixture of incredible luck as well as examples of time-tested design and vision.

One feels a similarly mysterious enchantment upon examining the fragmented remains of the Aqua Theater. It is a truly moving experience for one to close his or her eyes and imagine the thousands of people lining up, cheering deliriously, applauding, dazzled by high-dive tricks or being absorbed by an overture echoing across the night waters of the lake. In pondering this once exceptional structure, one finds a window, not only into the spirit of the lake, but also into the dreams and possibilities of another era.

William D. Wood wrote, "No other city in the Union has within its limits such a symmetrical and available frontage for public recreation and enjoyment of natural beauty as is afforded by the situation of Green Lake. It is to be hoped that the city of Seattle and her citizens will secure and preserve all features of this opportunity before any of them pass away or attain values which shall delay or prohibit their acquirement." Today, to find that shiver of serenity, one needs only to turn away from the street; gaze across Green Lake with the bustling city at their back; and appreciate that this opportunity for freedom and tranquility exists and that Wood's words were truly taken to heart by so many.

Although the feeling seems wondrous, the story is very real. In hard times and in times of celebration, this natural landmark has been bringing a community together for generations past and will be for generations to come.

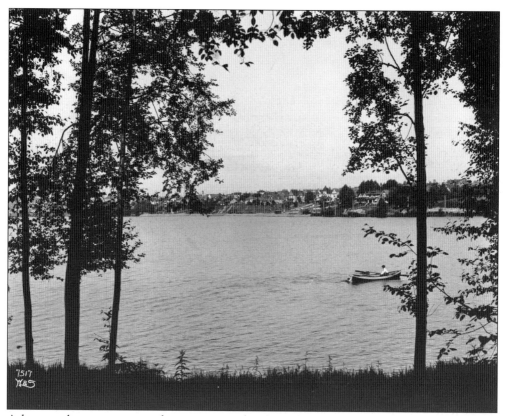

A lone rowboat punctuates the serenity in this framed view from the shores of Green Lake near Woodland Park c. 1912. (Courtesy PEMCO Webster and Stevens Collection, MOHAI, 1983.10.7849.2.)

One

A BEGINNING

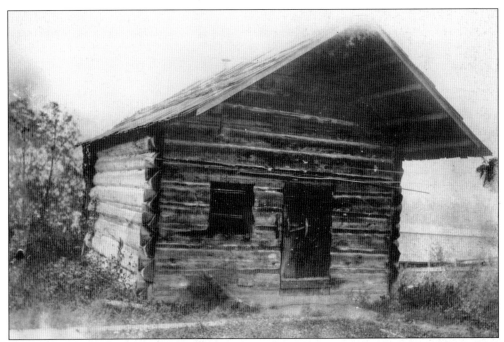

In October 1869, a German immigrant by the name of Erhart Siegfried (1832–1899) claimed approximately 130 acres of land and built the first log cabin on Green Lake's north shore. He was 37 years old at the time and worked for Thomas Mercer on a farm on Lake Union. For the next decade, his cabin, where he lived with his wife, Eltien, stood alone on the lake. Later he would be known as "Green Lake John." (Courtesy University of Washington Libraries, Special Collections, UW9033.)

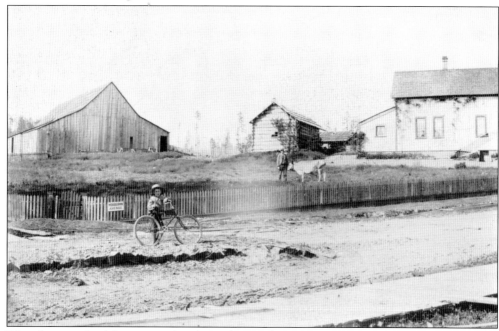

This photograph of that same cabin (center) was taken in 1897, ten years after Siegfried sold his holdings to Mayor William D. Wood (1858–1917) for $15,000. The sign on the fence, which says Woodlawn Avenue, is currently the corner of Northeast Seventy-second Street and East Green Lake Drive North. This was Wood's residence at the time. (Courtesy University of Washington Libraries, Special Collections, UW6054.)

This is the Wood house again, this time from a different angle up the street. The boy at the bottom of the steps, with his hands tucked in the chest of his bib overalls, appears to be standing beside a small mailbox fixed to the left of the gate. One can assume that the wooden ramp he stands in front of is temporary since it arches over beams, which are probably the first phases of some kind of early neighborhood walkway.

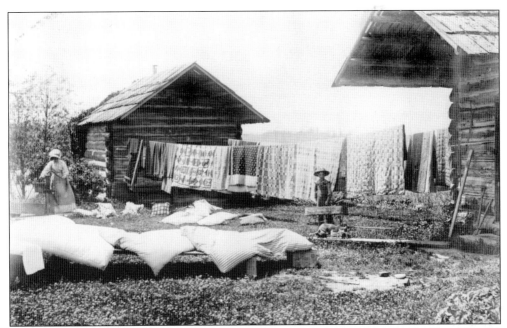

In this c. 1900 photograph, a woman washes and hangs quilts between Siegfried's (then Wood's) cabins, the latter of which was torn down in 1914. The hat on the person to the right suggests that this may also be the boy present in the previous two photographs. (Courtesy University of Washington Libraries, Special Collections, UW593.)

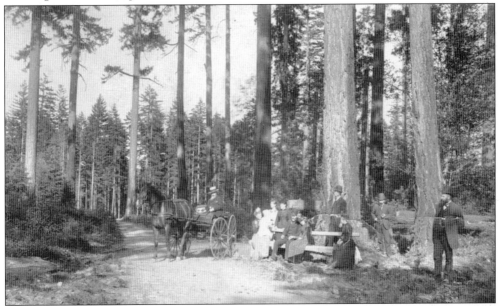

The bearded man on the far right is Guy Carleton Phinney (1852–1893). The eastern half of his Woodland Park estate, which he purchased in 1889 from businessman Charles Waters, ran contiguous with Green Lake. A wealthy immigrant from Nova Scotia and lumber mill owner, he helped develop much of the real estate in the area. The description given locates this group at the top of Woodland Park, where the old road from there to Green Lake began in 1891. (Courtesy Seattle Municipal Archives, Item No. 30715.)

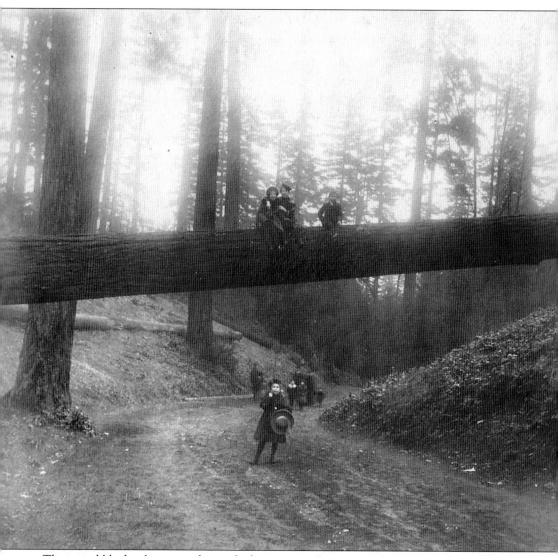

The incredible developments that took place in just a few years in the Green Lake neighborhood had much to do with the visionary accomplishments of Guy Phinney. His plans for the 200 acres of forest—and the swift steps he took to achieve them—were inspirationally vast. These plans included, but were certainly not limited to, a mansion, a ballpark, picnic grounds, a conservatory, and an assortment of animals, all of which would become the foundation for a much-revered attraction of northern Seattle—a companion recreational center to Green Lake. (Courtesy Julie Albright.)

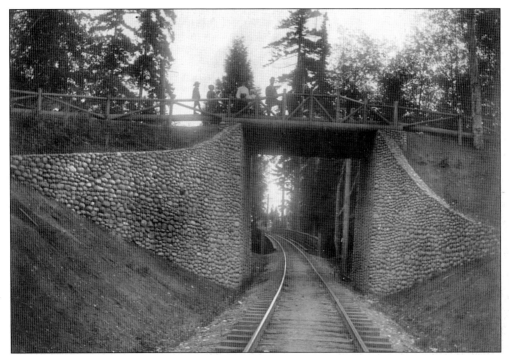

Starting in 1889, Phinney was a major player in expanding transportation to the area when he formed the Woodland Park Electric Railway. From 1890 to 1897, this private trolley line took passengers north up Fremont Avenue to Woodland Park, ending on North Fiftieth Street. (Courtesy Julie Albright.)

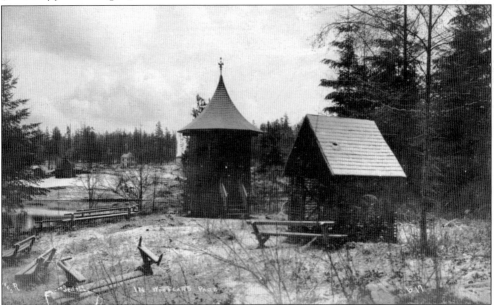

Guy Phinney died, in the midst of so many valuable designs, at age 42 in 1893. He would never meet John C. Olmsted, the man who would forever change the face and function of his estate. Left with the massive creation, the widow, Nellie Phinney, agreed to sell the park to the city for $100,000. This photograph of Woodland Park was probably taken around that time.

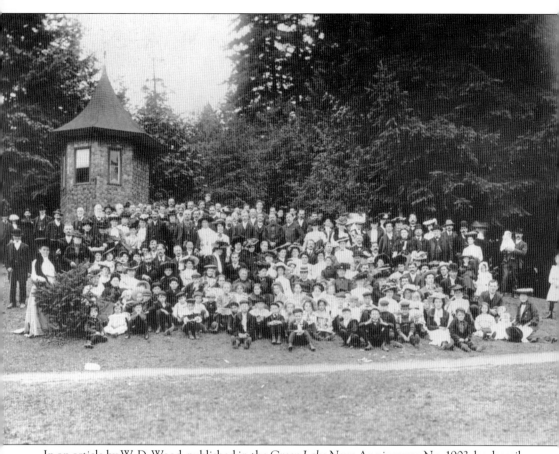

In an article by W. D. Wood, published in the *Green Lake News* Anniversary No. 1903, he describes Phinney's "enthusiasm for natural beauty" and "unselfish preservation of Woodland Park" thusly, "Mr. Phinney did not do this with a view to his future profit. It was always in his conception a private ideal and enjoyment. It is fortunate that his heirs and the city were willing to arrange that it should become public property, but Mr. Phinney himself did not found it with that result in view. His devotion to Woodland Park was entirely free from mercenary purpose." This photograph shows a large group in Woodland Park at the south end of Green Lake in 1891.

In 1904, Woodland Park Zoo opened according to the plans of John Olmsted and, in 1906, the streetcar route to it was restored to use. An adjoining rose garden was planted in 1922. The zoo is currently home to roughly 300 species of wildlife, and both are regarded among the best of their kind in the United States. (Courtesy Julie Albright.)

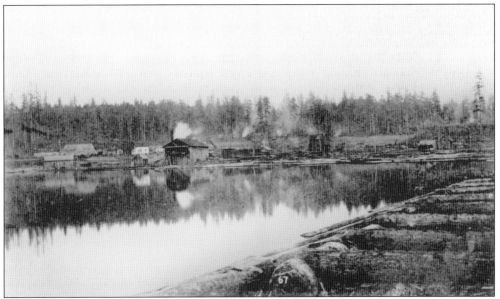

The proprietor of this sawmill, located on what was then the northeast shore of the lake, was Andrew L. Parker. Opening in 1890, at roughly the time when this was taken, his mill was the feature point at the Woodland Station stop on the Green Lake Electric Trolley route. The cove at the Ravenna outlet, where Parker's mill rafted logs, would be one of the major fill alterations suggested by Olmsted and the eventual host to Evans Pool and the Recreation Center. (Courtesy University of Washington Libraries, Special Collections, PEISER67.)

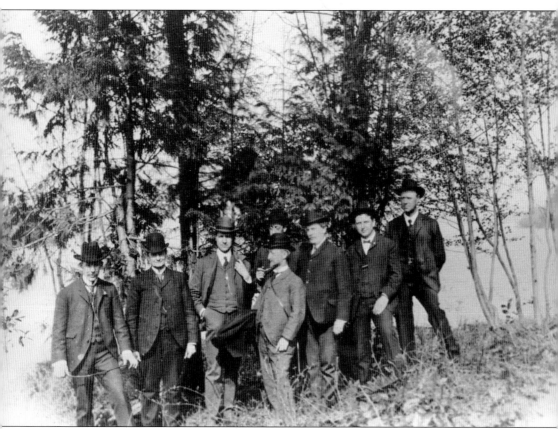

John Charles Olmsted (1852–1920), of Olmsted Brothers landscape and architecture firm from Massachusetts, arrived in Seattle on April 30, 1903, to survey the city for which he had recently been hired to devise most of the major parks and boulevard systems. The following day, this photograph was taken with John Olmsted in profile in the foreground. With his assistant Percy Jones, Olmsted would also design the park system for Portland, Oregon. As the stepson of Frederick Law Olmsted, the designer of Central Park in New York City, his rigorous evaluations and the enchanting designs that followed would form manifold sources of joy and beauty for generations to come. The gentlemen, from left to right behind him, are E. F. Blaine, Capt. Pratt, E. F. Fuller, Percy R. Jones, C. W. Saunders, J. E. Shrewsbury, and A. L. Walters. (Courtesy Seattle Municipal Archives, Item No. 31004.)

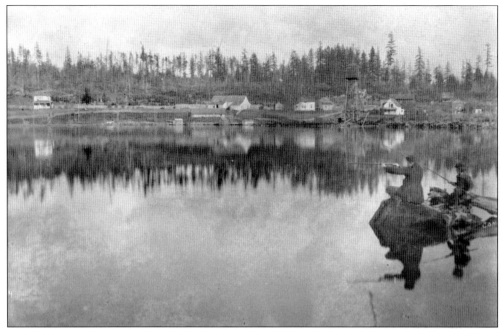

An unidentified man points his rifle alongside a youth with a fishing pole in this 1896 photograph. Few of the characteristics in this view would survive Olmsted's profound revisions.

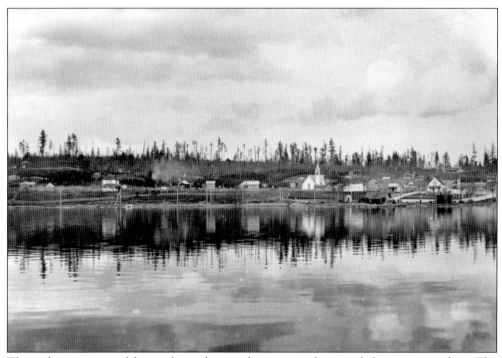

This is the same view of the northeast shore as the previous photograph four or so years later. The caption identifies the white building, roughly a quarter of the image width in from the left, as 7419 Corliss Avenue—a structure that still stands on the lake. (Courtesy MOHAI, SHS2796.)

In this 1891 view toward the eastern shore, the contrast of the clearings against the remaining denser sections is somewhat startling. The foreground features seemingly endless piles of lumber stacked beside Phinney's boathouse. It is easy to see how swiftly the landscape was altered as progress took hold, as well as why Parker would shortly thereafter need to relocate his sawmill.

At this time, Green Lake still represented a relatively untrammeled slice of nature close to the city. Its quiet waters reflected a vanishing era as urban growth would soon spread along its shoreline.

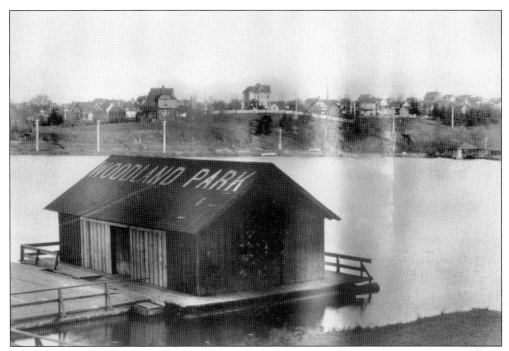

As weekend excursions became increasingly popular for those seeking to escape the city, Green Lake experienced an exposure instrumental to its transition from a getaway to an independent, fully functioning neighborhood. (Courtesy MOHAI, SHS12350.)

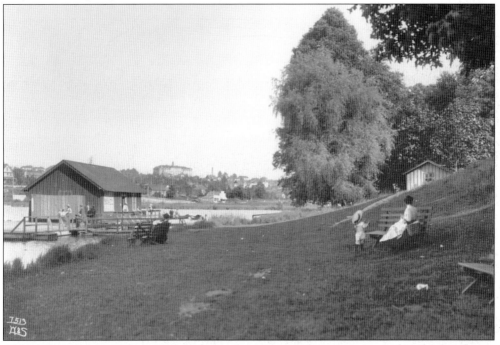

Although powerboats were eventually banned on Green Lake, one was stored in this boathouse for emergency purposes in the 1950s. The slight rise on this part of the eastern shore proved ideal for winter sledding. (Courtesy PEMCO Webster and Stevens Collection, MOHAI, 83.10.7847.)

The couple seated side-by-side on this rustic wooden bench emphasizes the pristine, intimate quality that eternally enticed Green Lake's patrons. Its variety of niches provided absolute serenity, perfect for calm introspection or shared reflections. (Courtesy PEMCO Webster and Stevens Collection, MOHAI, 83.10.7856.)

Even after paths were made and the area was formerly arranged as a more dignified park, it was clear—and still is to this day—that citizens of Seattle were proud of the lake, understood its value, and were determined to preserve its natural enchantments. (Courtesy PEMCO Webster and Stevens Collection, MOHAI, 83.10.7855.)

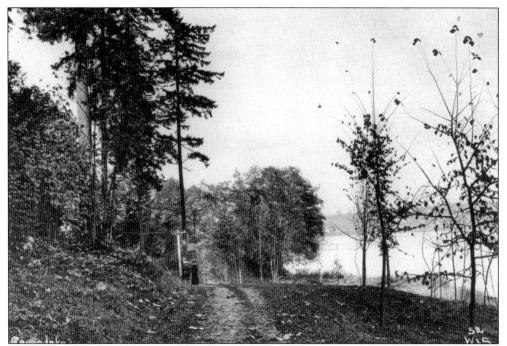

In this image, the viewer can just discern the two women sharing a secluded stroll along the coarse lakeside path, almost certainly enjoying the clear autumn air.

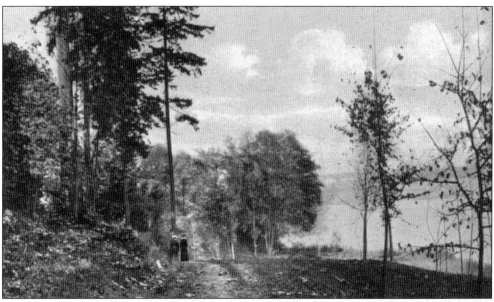

A common practice when reproducing images for postcards involved retouching spaces and other alterations for sales purposes as well as to form a more attractive idea of what the area had to offer to prospective visitors. In this example, the women from the previous, unaltered photograph are slightly more visible, ersatz clouds have been added in the upper right corner, and the utility pole to the left of the women has been removed. (Courtesy Clinton White.)

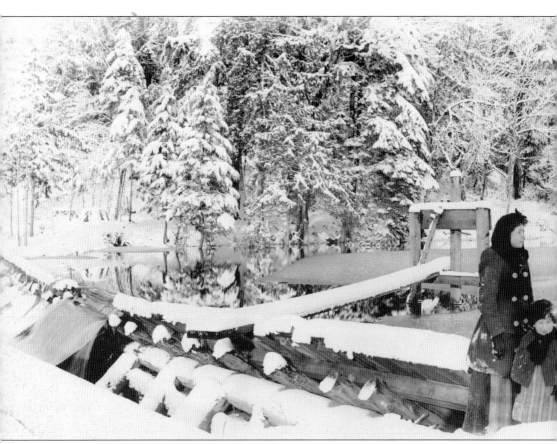

In the midst of a tremendous snowfall during the winter of 1893, these bundled-up visitors were witness to six inches of ice on the lake in conditions at five degrees below zero; temperatures have rarely dipped as low ever again. Behind them, the old drainage outlet on the east side flows into Ravenna Ravine. (Courtesy University of Washington Libraries, Special Collections, SEA1074.)

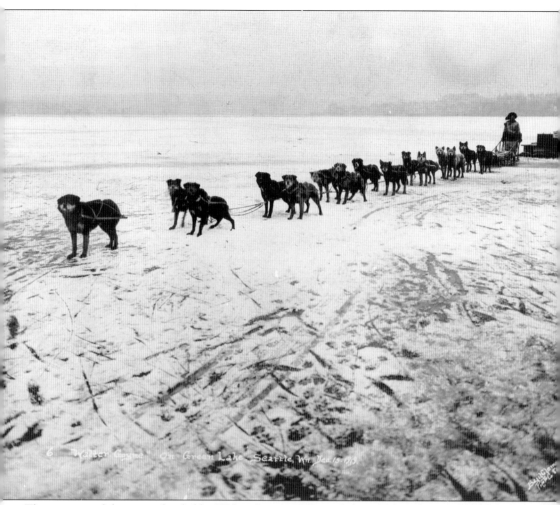

This image is of champion dogsledder Walter Goyne on Green Lake on December 15, 1919. When winter recreation was still allowed, police officers kept watch on skates, and barricades were put up around the areas that were deemed unsafe. After the mid-1940s, the lake rarely managed to reach the five to six inches of ice required for permitted adventures out onto its surface. (Courtesy MOHAI, SHS2268.)

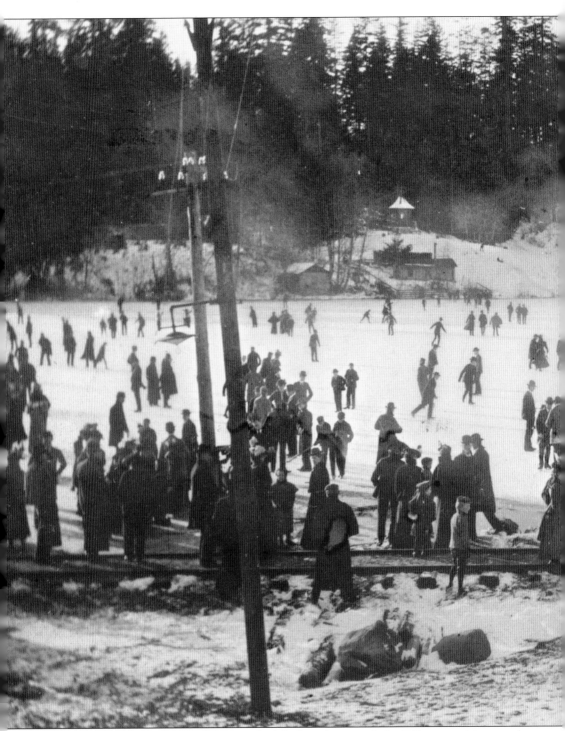

Ice-skating was not only a tradition on the lake but also provided a different social atmosphere for the neighborhood—the delight of winter twilight bursting with bonfires, music, and clamp-on skates. This was a time when new friends were introduced in chilly, huddled circles, and couples shared their first enchanted moment hand-in-hand with the cold wind in their faces. In this 1902

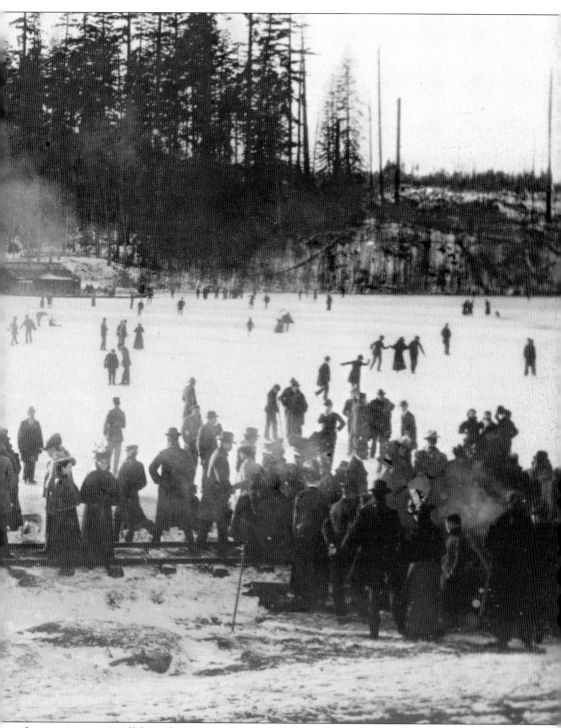

depiction, one can tell from the strange chunk of clear-cutting to the right that urbanization was undergoing a rapid transition from initial to intermediate status. Each year, skating visitors would see a noticeably different Green Lake. (Courtesy MOHAI, SHS1760.)

Sharing a view of the south end with these onlookers, in the distance the rather impressive residence of Judge Frederick A. McDonald can be seen. In 1898, McDonald was elected to the state legislature and became minority floor leader. (Courtesy University of Washington Libraries, Special Collections, UW1630.)

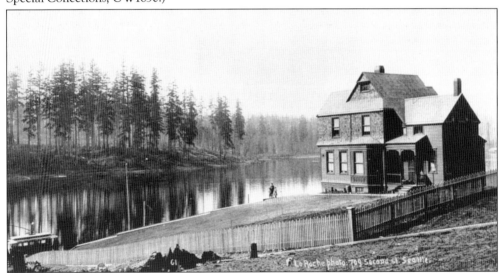

McDonald was a supportive partner to William D. Wood and Edward Corliss Kilbourne (1856–1958, electrical engineer) in developing the district by expanding the Green Lake trolley line to travel around the east side. Here is a closer view of the McDonald house, c. 1891. (Courtesy University of Washington Libraries, Special Collections, LaRoche61.)

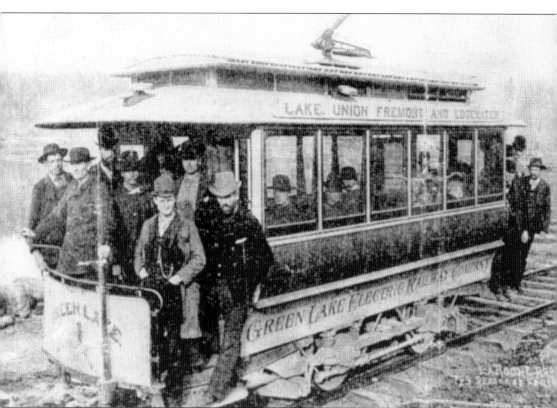

In 1889, Kilbourne had claimed 80 acres on the east side of the lake. He eventually married Leilla A. Shorey and took up a brief residence in the neighborhood in a house on North Sixty-third Street. Meanwhile, Wood developed a 10-acre amusement park at the end of the extended Green Lake line, which was located where the Bathhouse Theater currently stands. This is Green Lake Electric Railway Company Car No. 1, *c.* 1890. (Courtesy University of Washington Libraries, Special Collections, LaRoche591.)

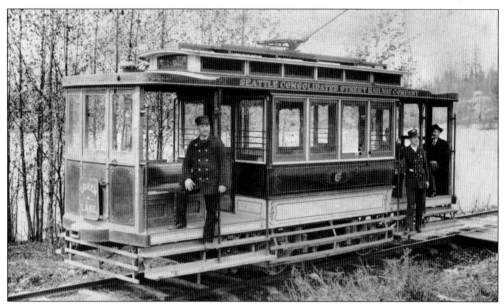

However, by 1909, the amusement park at the northwest corner of the lake had long ceased to operate and had become known as the "Old Picnic Grounds." Its brief existence remains a remarkable curiosity for those residents who wish they could have seen such a marvelous spectacle on their lake. This is a c. 1894 image. (Courtesy University of Washington Libraries, Special Collections, UW5481.)

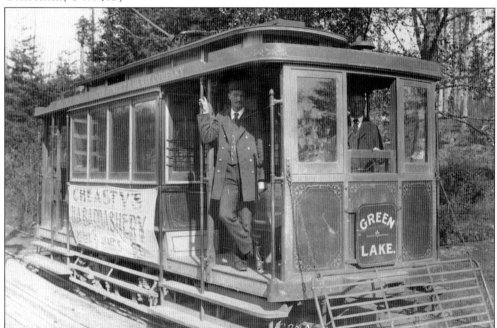

Kilbourne, also co-investor and organizer of West Street & Lake Union Electric Railway, became majority owner of the future Union Electric Company after the electric-lighting plant was destroyed in the great Seattle fire of 1889. After his retirement in 1910, Kilbourne acted as an avid philanthropist for the YMCA. Seattle trolley services were finally discontinued in April 1941. (Courtesy Seattle Municipal Archives, Item No. 29246.)

As the neighborhood took shape, and large properties were being divided and resold, the inspiration to establish a variety of businesses quickly spread. The sign for this hardware store reads, "J. W. Rafferty & Co." The man second from the left in the white hat is the owner, John W. Rafferty, and to the far right is E. D. Rafferty. The caption provided with the 1906 photograph places the business on East Seventy-second Street between Woodlawn Avenue and East Green Lake Way, and identifies one of the two individuals between the Raffertys as Isaac Campbell. (Courtesy MOHAI, SHS9759.)

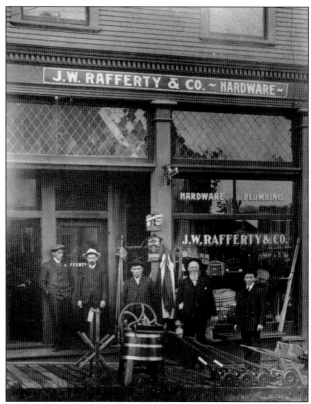

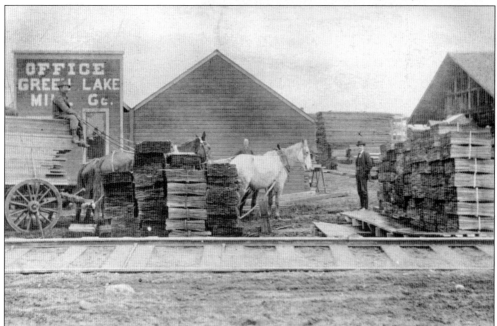

Here, in 1904, on the spot where the Fieldhouse now stands, is Green Lake Mill Office, located at 6962 East Green Lake Boulevard, where a load of milled lumber appears ready for delivery. The man standing to the far right is documented as Walter Burleigh. (Courtesy MOHAI, SHS15439.)

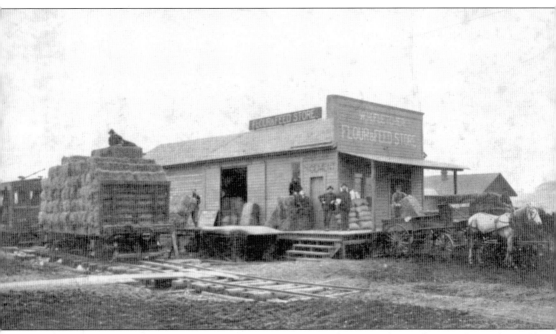

This photograph, also taken around 1904, provides a view just down the way from the Mill Office to the W. H. Fletcher Flour and Feed Store, located at 7107 East Green Lake Boulevard. Fletcher's store was a very important stop for freights on the lake. As the *Green Lake News* described it around this time, "For the accommodation of his business the electric company has built a switch running to the store platform where an average of ten tons of supplies are delivered every day." The caption suggests that somewhere in the scene E. Burleigh is ordering hay. He is likely a relative of the man pictured at the mill office in the previous photograph. (Courtesy MOHAI, SHS12350.)

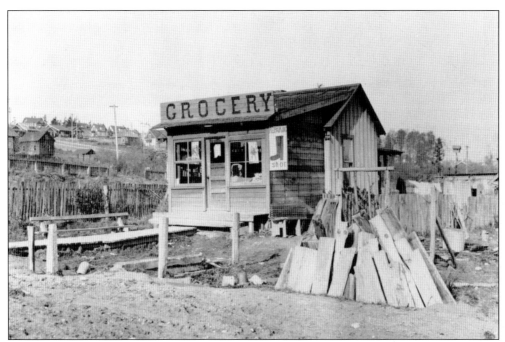

Against the more advanced developments visible in the background, this early Green Lake grocery appears to be a work in progress. An illustrated sign to the right of the windows reads, "Repairing Shoe." Dominating the lot is a curiously large pile of firewood. The photograph is dated November 14, 1911. (Courtesy University of Washington Libraries, Special Collections, Lee75.)

In this 1894 image, two children converse while casually wetting their feet on the shore of the lake alongside Woodland Park. Assuming they were residents enrolled in the rapidly changing Green Lake School at this time, it is likely they were very familiar with the principal, George W. DeBolt, a man whose tasks were endless and whose efforts key to the success of the students. Soon their social worlds would expand at an astonishing rate and under conditions barely conceivable today. (Courtesy University of Washington Libraries, Special Collections, UW472.)

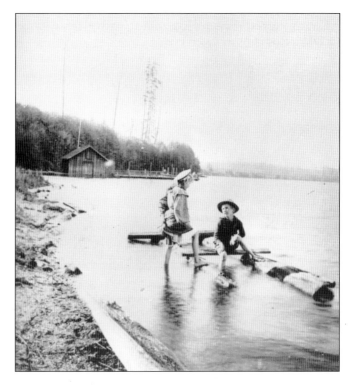

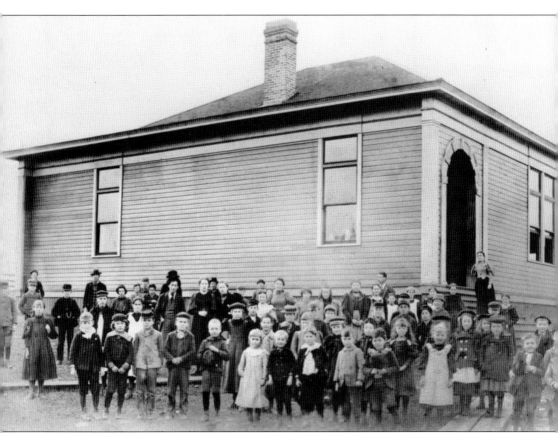

The Green Lake School, which opened in 1891 with an enrollment of 38 students, is pictured here around 1896 at Sunnyside Avenue North and North Sixty-fifth Street. It was built on a 10-lot property donation from W. D. Wood. Prior to the erection of this building, the original Green Lake schoolhouse, located at Northeast Fifty-sixth Street and Twenty-fifth Avenue Northeast, was a small cabin that held less than half that amount of pupils. The woman on the steps in the photograph is identified as Mrs. Livermore. (Courtesy University of Washington Libraries, Special Collections, UW18624.)

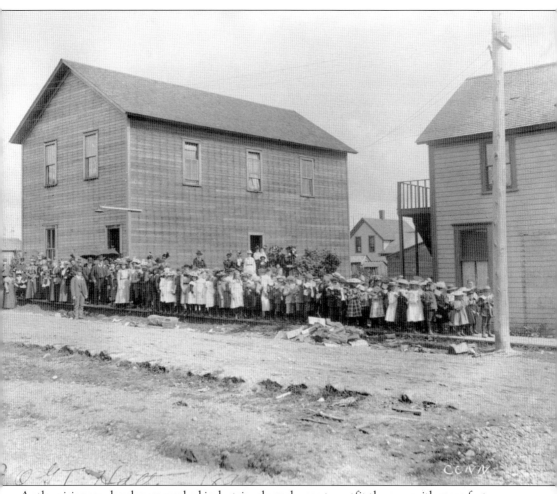

As the visionary developers worked industriously each year to outfit the area with more features, the enrollment surged. In 1898, around the time this photograph was taken, the school underwent a two-room addition, and three years later, two annexes were opened to quickly but temporarily accommodate the overwhelming growth. One was at the Northeast Seventy-second Street and Fifth Avenue Northeast International Organization of Good Templars (IOGT) Hall (pictured here on the left), and the other was at the present location of the John Marshall School. One of the teachers at the time, probably somewhere in this photograph, was Miss Reisdorf. The building on the right is the local grocery store, which doubled as the Green Lake post office, where postmaster Matilda Petersen lived and worked. (Courtesy University of Washington Libraries, Special Collections, SEA1456.)

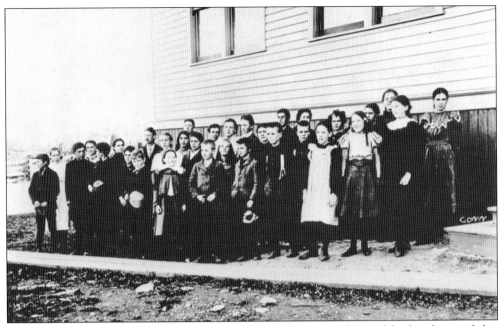

A powerful indication of the astounding progress of the Green Lake neighborhood around this time was the increase in the Green Lake School enrollment in 1901 to 445 pupils. In just 10 years, the student body had increased by tenfold since the school first opened in 1891. (Courtesy University of Washington Libraries, Special Collections, UW5044.)

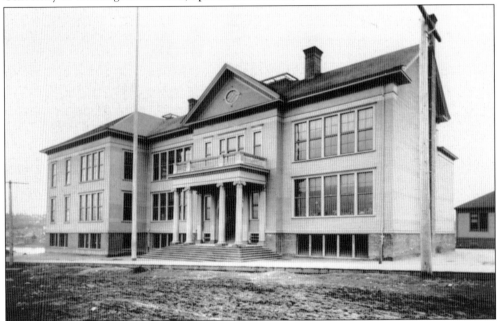

By 1902, the new Green Lake School, pictured here, was constructed on lots bordering the original site. Once its enrollment reached just over 900 students about five years later, new schools around the area went up approximately every two to four years, including Daniel Bagley Elementary, the Fairview School, John B. Allen Elementary, and the F. A. McDonald School. (Courtesy University of Washington Libraries, Special Collections, A.Curtis04315.)

Daniel Bagley, pictured here around 1895, figured prominently in the beginnings of Seattle. A Methodist preacher and Master Mason, he traveled to the Northwest in the same wagon party as Thomas Mercer, established the Brown Church (Second Avenue and Madison Street downtown), assisted in running the Lake Washington Coal Company, aided in the founding of the Territorial University of Seattle, and acted as president on its board of commissioners. Daniel Bagley Elementary School was given its official name on March 27, 1906. His son Clarence Bagley married Thomas Mercer's youngest daughter, Alice. (Courtesy MOHAI, MP1976.6310.1.)

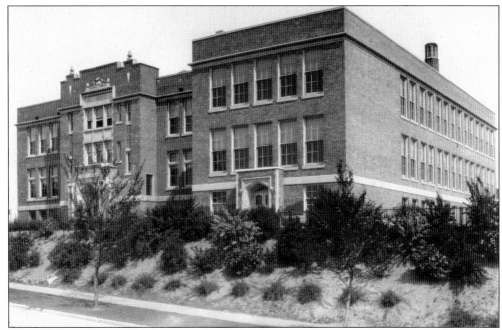

Fairview School, located at 844 Northeast Seventy-eighth Street, was built in 1908 and was closed by the Seattle Public School District in 1978. Purchased in the 1980s by the Woodland Park Avenue Church, it now serves as a place of worship in addition to hosting grades preschool through eight. (Courtesy PEMCO Webster and Stevens Collection, MOHAI, 1983.10.4203.)

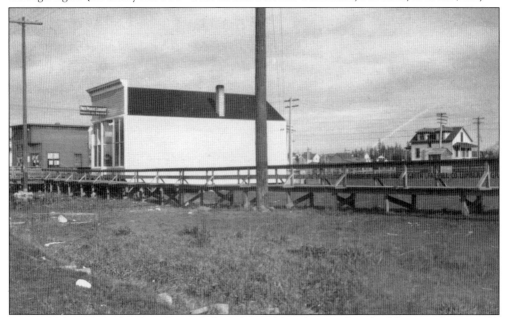

From 1905 to 1910, the first Green Lake Library (the closest white building in photograph) consisted of a small building near the Ravenna outlet where the Albertsons grocery store was recently located. But soon, just as the schools were bursting at the seams, the members of a new and flourishing community realized that the density of the neighborhood demanded a more extensive collection.

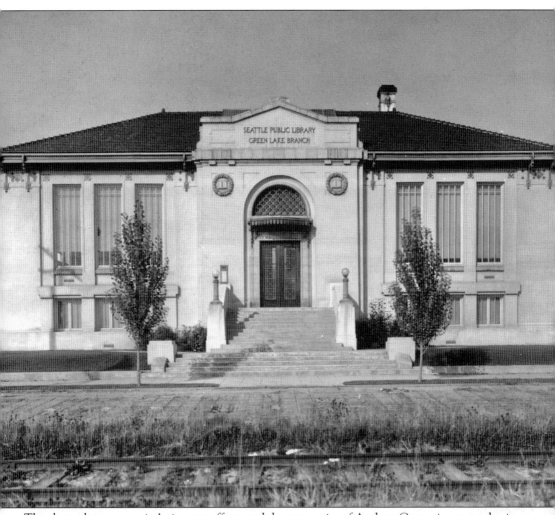

Thanks to the community's rigorous efforts and the generosity of Andrew Carnegie, an emphatic supporter of free public libraries around the world, that objective came to fruition. On July 29, 1910, the Green Lake Library, seen here *c.* 1916, opened its doors with a ceremony at which Judge F. A. McDonald gave one of the key speeches. (Courtesy MOHAI, 1983.10.10162.1.)

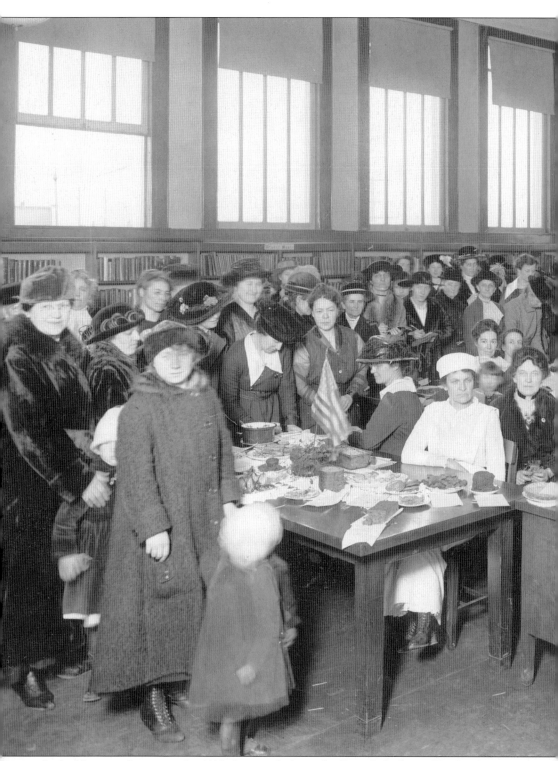

In the library reading room, this 1919 photograph shows the Green Lake Parent-Teacher Association (PTA) holding what is referred to in its caption as a "food exhibit." To the right, members display

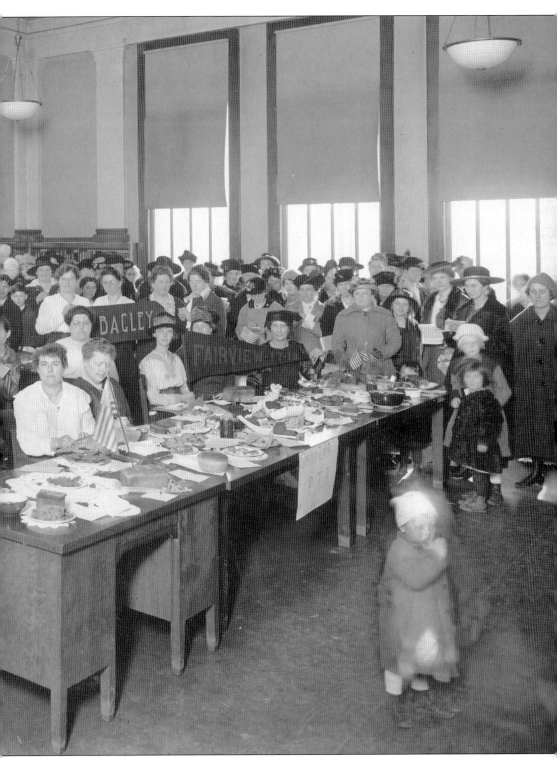

the Bagley and Fairview school banners.

Prior to the construction of the brick bathhouse and the field-house recreation center, a previous wooden bathing station, with roofless dressing rooms, existed closer to the southwest area of the shore. This photograph was taken in 1914, the year that the original bathing station was built. The enclosed structure in which these children are swimming was probably adjacent to the facility.

As in numerous early summertime moments, youths are depicted here crowding a chosen corner for their lakeside diversions. The lake became so popular that the former wooden bathing station needed to be expanded within less than a year. (Courtesy MOHAI, 83.10.7851.)

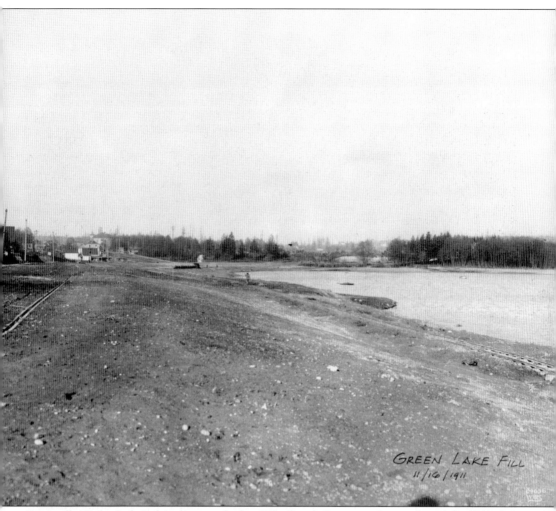

GREEN LAKE FILL
11/16/1911

Originally Green Lake's shoreline reached to Fifty-fourth Street on the south end. In 1911, due to a lack of undeveloped land along the shore, John Olmsted implemented a plan to lower the water level of the lake by approximately seven feet and then filled the exposed areas in order to establish about 100 acres of additional land. This image was taken on November 16 of that year, documenting the beginning of the filling endeavor. In the far distance, men are visible bringing dirt to the shoreline.

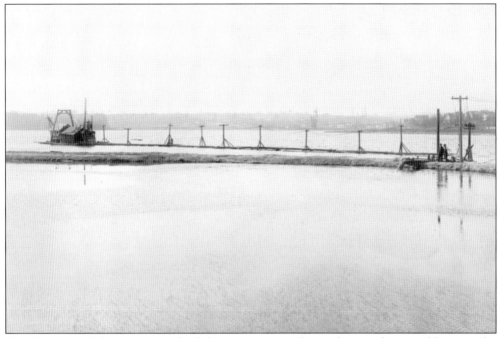

The first stage of the project involved the construction of a trestle extending roughly two miles offshore. It was used as a means of transporting dirt for creating a dike.

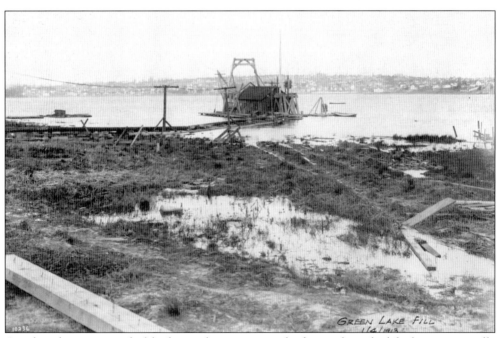

Another phase consisted of dredging a large amount of sediment from the lake bottom, initially intended for filling use. However, it was soon discovered that the material was too light when dry for that purpose.

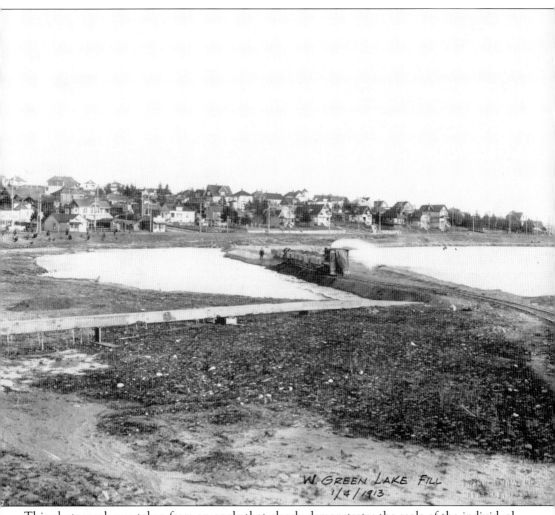

W. GREEN LAKE FILL
1/4/1913

This photograph was taken from an angle that clearly demonstrates the scale of the individual parts of the filling process, as the large lake dwarfs a narrow-gage engine tipping cars carrying fill into the sectioned-off area along the dike.

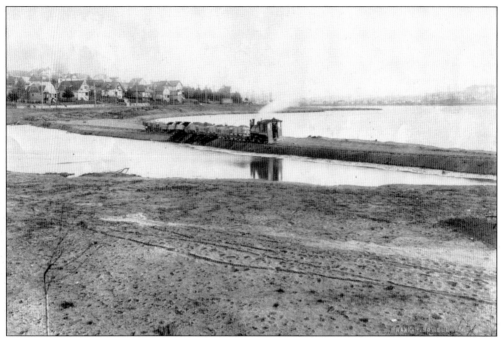

The project took over 20 years in its entirety. It was completed following the excavation of Woodland Park during the construction of Aurora Avenue in 1932. Material from the excavation was used to finish up the filling process.

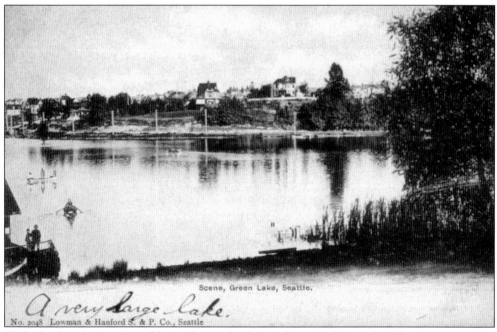

Scene, Green Lake, Seattle.

A very large lake.

No. 2048 Lowman & Hanford S. & P. Co., Seattle

With the foundations forged by settlers and cultivated to suit the needs of future generations, Green Lake had begun to achieve the successful underpinnings of a community.

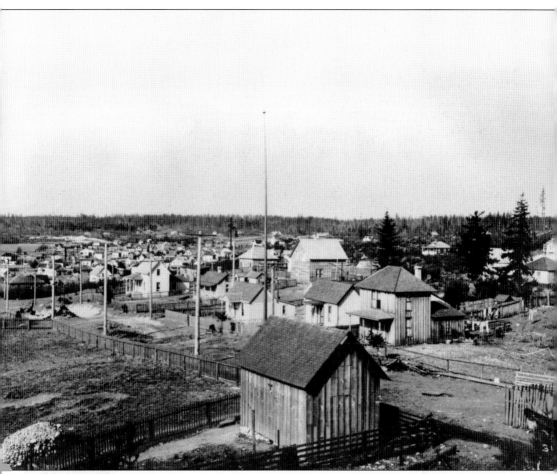

As the first substantial developers realized a geographical potential unique to the rest of the city, they worked tirelessly to solve the problem of rendering the entire Green Lake Park and neighborhood accessible. (Courtesy University of Washington Libraries, Special Collections, A.Curtis03151.)

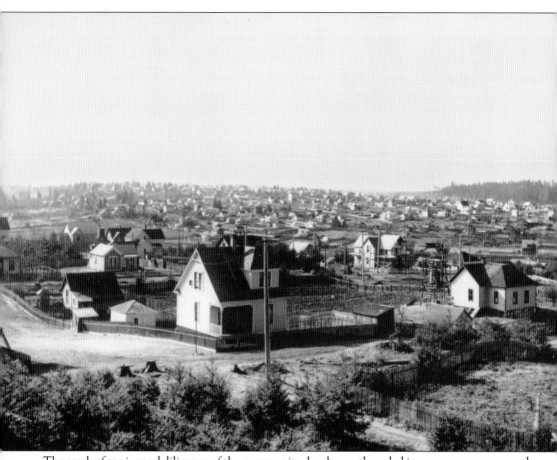

The mark of genius and diligence of the community developers threaded its way more permanently around the perimeters of a new neighborhood with tracks, roadways, pathways, and parks, planting the seeds of a vital new residential and business area. (Courtesy University of Washington Libraries, Special Collections, A.Curtis03153.)

Two

A Community

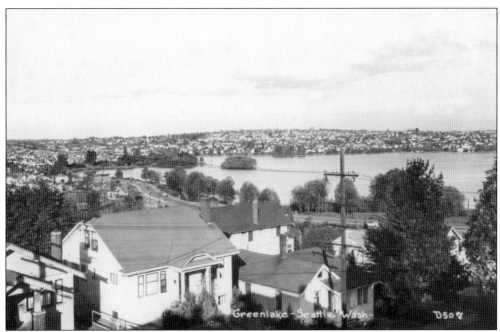

With an understanding of the framework of the early visionaries, one begins to see how Green Lake's landmarks and features contribute to the neighborhood as it is today.

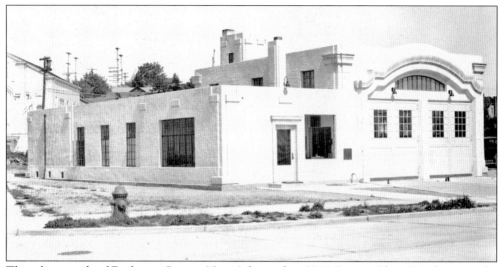

This photograph of Firehouse Station No. 16, located at 6846 Oswego Place Northeast in the Green Lake neighborhood, was taken in 1928, just after the station was built. In 1986, the interior was remodeled for more modern use along with basic window and roof renovations. However, it is one of few stations dating from this era that has not been expanded from its original size. (Courtesy Seattle Municipal Archives, Item No. 2933.)

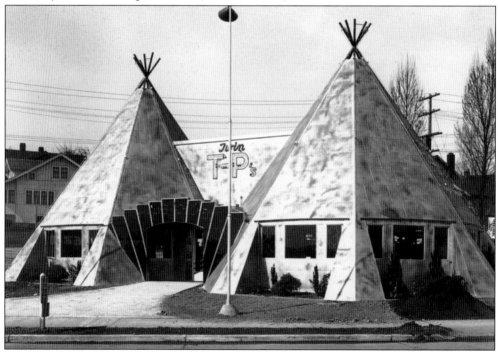

The Twin Teepees Restaurant, located at 7201 Aurora Avenue North, opened in 1937 at a time when the popularity of the automobile inspired businesses to compete with new, creative, and often times bizarre architectural attractions. Originally managed by Herman Olson, the sign over the entrance offered "Steaks [and] Chicken," as well as other, reasonably priced American meals. Five years later, the operation was taken over by Walter Clark, who owned a variety of different restaurants in the city. (Courtesy *Seattle Post-Intelligencer* Collection, MOHAI, 86.5.11405.)

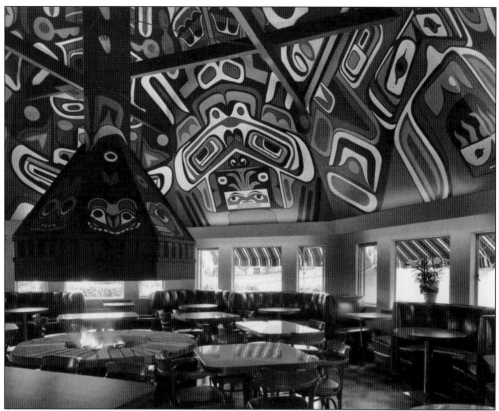

The interior of the Twin Teepees featured a Northwest Coast Indian motif, an open fireplace with a family dining area located in one 'teepee' of the structure, and a cocktail lounge in the other. Supposedly the famous Col. Harland Sanders of Kentucky Fried Chicken was a friend of Clark's and helped with recipes in the Twin Teepees kitchen. (Courtesy PEMCO Webster and Stevens Collection, MOHAI, 1983.10.18141.)

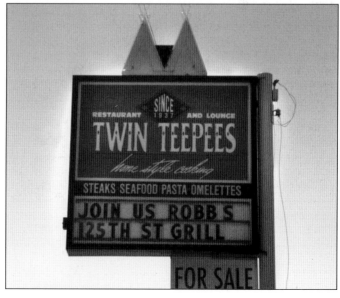

For a period in the 1960s, the name of the establishment was changed to Powers Pancake House. Later, following fires in the late 1990s and in 2000, the Twin Teepees closed. It was finally demolished in 2001.

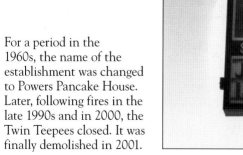

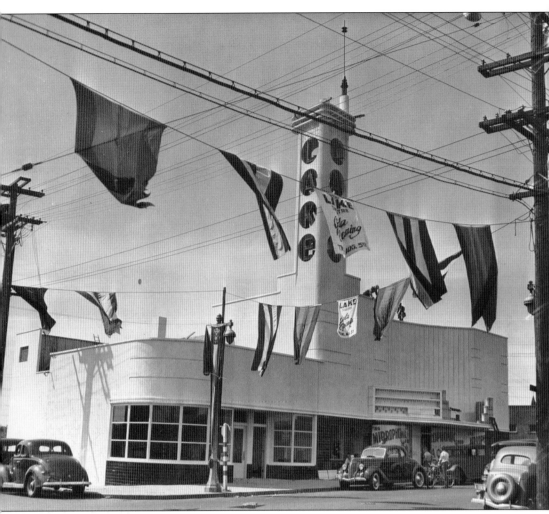

Not long before this was taken, the second movie theater situated in the Green Lake neighborhood opened on August 5, 1937, at 7111 Woodlawn Avenue with the film *Three Smart Girls*. It had been nine years since the first neighborhood cinema, which was located at 312 East Seventy-second Street and which had featured silent films since 1914, had closed. The new Green Lake Theater seated 750 and operated until 1950. (Courtesy *Seattle Post-Intelligencer* Collection, MOHAI, 1986.5.12637.1.)

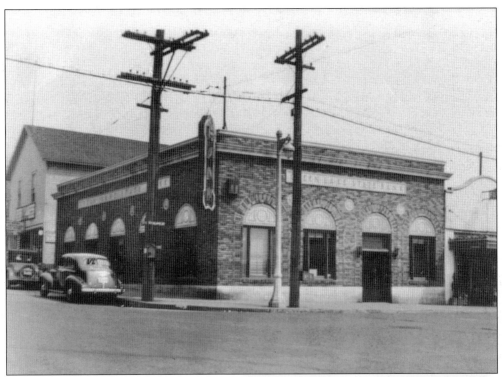

George Lear established the Green Lake State Bank, pictured here on the corner of what is now Northeast Seventy-second Street and Woodlawn Avenue Northeast, in the early 1900s.

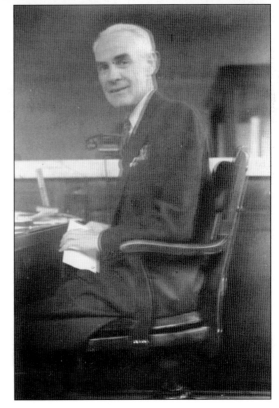

Later George Lear turned the bank over to his son Louis K. Lear, who was its president until it merged into the Seattle Trust and Savings in the late 1940s. Louis's brother-in-law William Warren, seen here at his desk, served as vice president.

In this photograph of the main doors to the Green Lake State Bank, William Warren stands between bookkeepers Evelyn MacPherson (left) and Eva Larson.

Nearly all of the bank employees lived locally and, as a consequence, socialized with one another outside of work as well. Associates were encouraged to know their customers by name, thus extending the atmosphere of congeniality. Pictured from left to right in front of the bank's main doors are Evelyn MacPherson, Dorothea Pfister, and Eva Larson.

This image shows James B. Hamlin, assistant cashier for many years, at his desk.

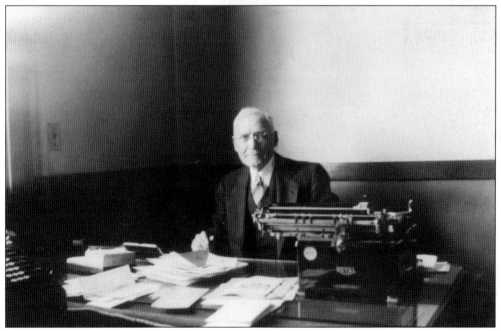

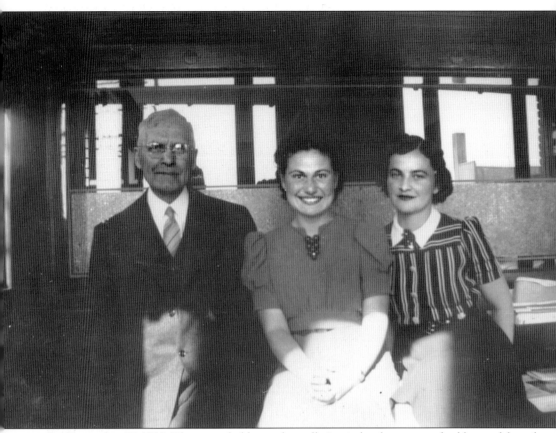

On September 27, 1938, Pfister was held up at her teller's window by an armed robber and forced to hand over the contents of her drawer. Luckily, president Louis K. Lear witnessed the robbery and quickly contacted police with a description. The suspect was apprehended later that day in Everett carrying $581 and a pistol. He confessed to the crime. Seated from left to right are James B. Hamlin, Dorothea Pfister, and Evelyn MacPherson.

Dorothea Pfister's family moved in 1919 to the Green Lake district of Seattle, where she attended the old Green Lake School, John Marshall Junior High, and Roosevelt High School. She held a variety of positions over the 10 years she was employed there, from 1934 to 1944.

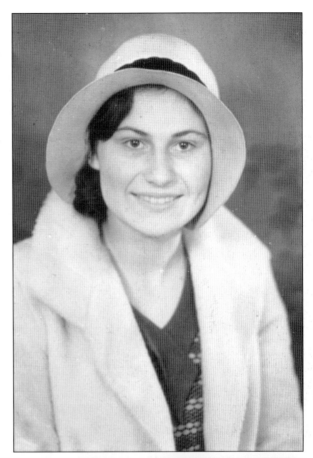

In this photograph, Pfister props her feet up triumphantly on her newly acquired desk, having just been promoted to assistant cashier. She held this job title until she married and retired in 1944.

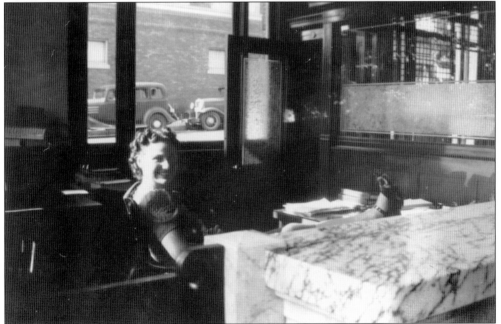

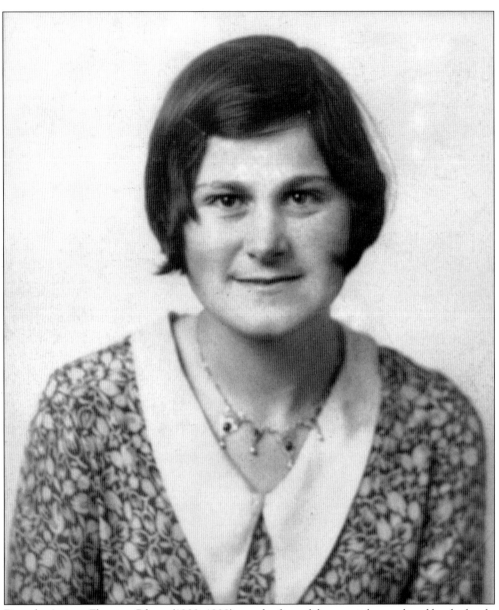

Dorothea's sister Florence Pfister (1909–1998) was the first of the two to be employed by the bank, from 1927 to 1934. Chosen as Miss Green Lake, she helped cut the ribbon at the opening of the George Washington Memorial Bridge (Aurora Bridge) in 1932. She married Joseph R. Burke in 1934 and raised three children.

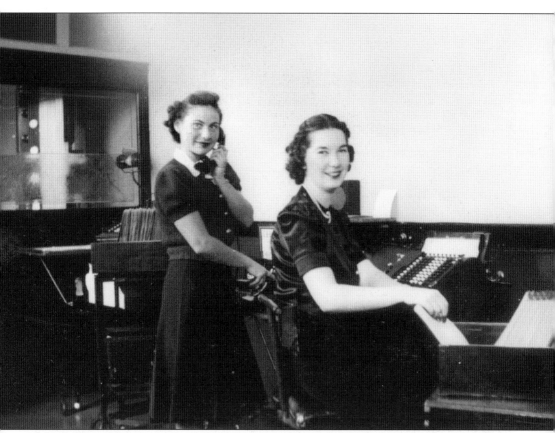

Today Dorothea (Pfister) Nordstrand works vigorously to capture her memories as a longtime resident, writing with enthusiasm and lucidity about the many changes her family and community went through. Her literary dedication to Green Lake is an unmatched, priceless contribution to the preservation of its history. Here, in the late 1940s, Dorothea stands at left with phone in hand, while Eva Larson sits on the right at her Burroughs bookkeeping machine.

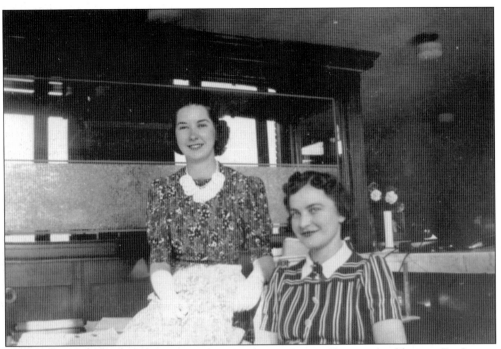

Pictured here are bookkeepers Eva Larson (left) and Evelyn MacPherson (right).

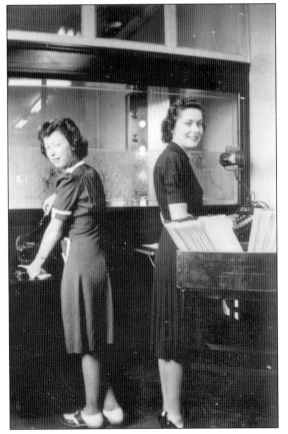

This is a candid view of bookkeepers Mary Campbell and Olive Nelson in the back room.

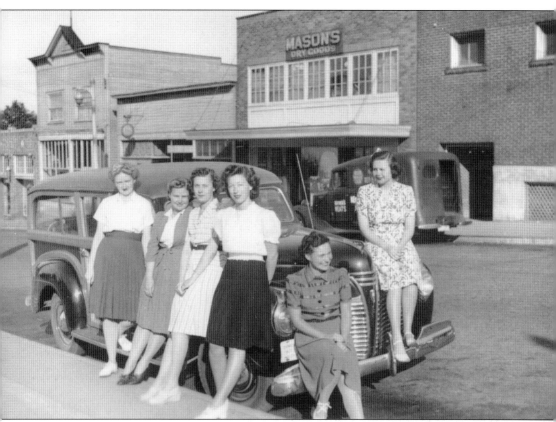

In addition to the Green Lake State Bank, Louis Lear was also president of Queen City Broadcasting Company (radio station KIRO). On this occasion, bank employees pose with the Queen City Broadcasting Company station wagon, which they were permitted to borrow for their weekend trip to Whidbey Island. Dorothea Pfister, seated on the bumper second in from the right, went along as designated driver.

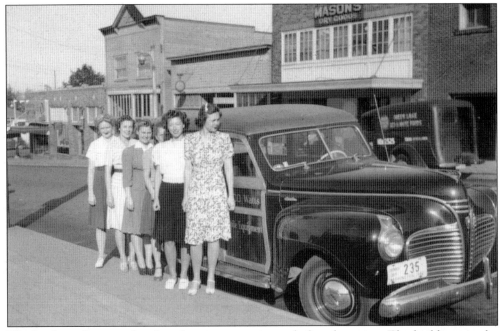

The bank workers stand in line for one more picture before departing. The buildings in the background on Northeast Seventy-second Street are, from left to right, a confectionary shop, a millenary shop, a jeweler, Mason's Dry Goods, and a grocery store (brick building).

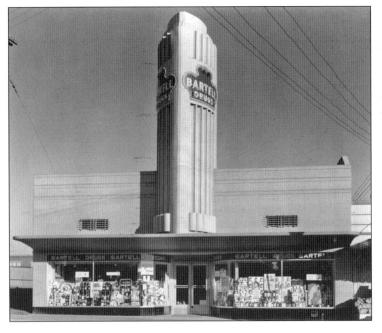

This Bartell Drugs, located then at 7804 Aurora Avenue, opened around the time this photograph was taken in 1940. The caption further notes that it was one of 21 Bartell stores existing at that time. A decade later, the towering pylon with the Bartell's logo would be gone, and the store was replaced with Chubby and Tubby, a home-and-garden supply store.

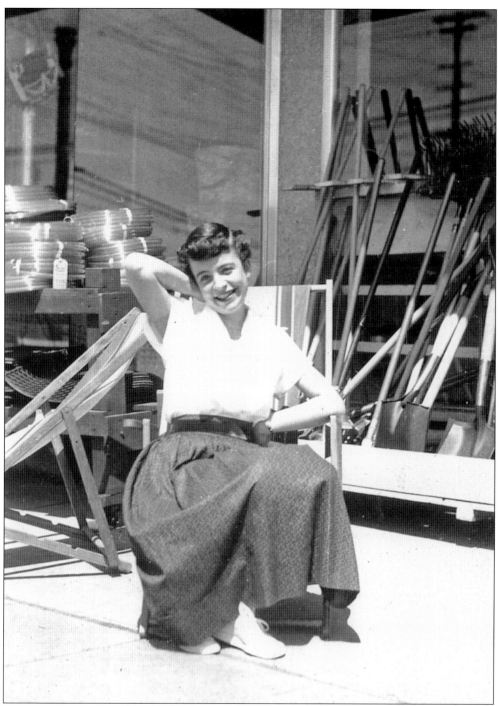

Joanne Strophy, at about age 16 in the early 1950s, flashes a radiant smile as she poses here amidst garden supplies in front of Chubby and Tubby, where she held her first job. Many years later, she would never forget the moment when her workday was personally interrupted over the speakers, as the KJR radio station announced the dedication, "To Jo, who's slaving away at Chubby and Tubby's," followed by "Secret Love" by Doris Day.

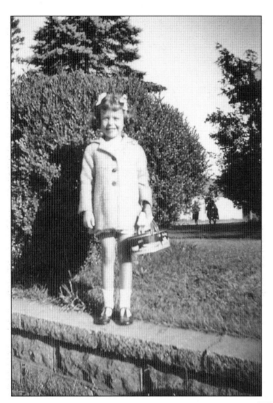

This is Joanne Strophy about 10 years earlier at her house 910 North Seventy-eighth Street, where she lived with her parents, John and Veronica, her sister Ronnie, and her brother Richard. This photograph was taken on September 7, 1943, as Joanne was carrying her lunch box on her way to her first day of first grade.

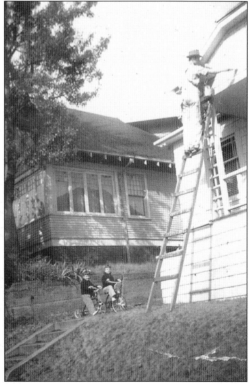

Here John Strophy reaches from the top of the ladder, applying a new coat of paint as his daughters ride their tricycles below. Mr. Strophy did most of the additions to the house himself—it was the place his family would live for 67 years, from 1930 until 1997.

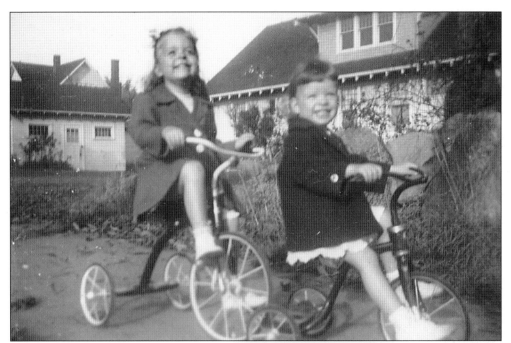

The Strophy sisters, Joanne (left) and Ronnie, gleefully peddle their bikes past their neighbor's house around 1941.

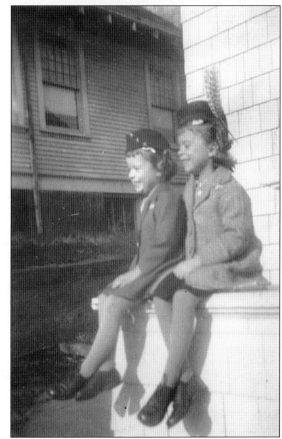

Here Ronnie (left) and Joanne pose harmoniously on the front ledge of their house in matching outfits. Their mother made these as well as most of their clothes—a common practice of the times.

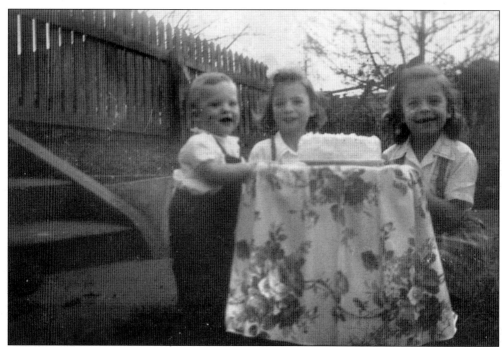

In their backyard on Seventy-eighth Street, the youngest sibling, Richard, celebrates his first birthday with his sisters in 1943.

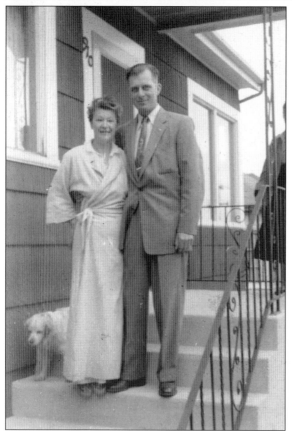

Veronica and John Strophy stand on the front porch of their house with the family dog, Snuppy, around 1955. John worked for the Railway Express Agency by Kings Street Station as a rail services salesman. Veronica worked part time in the 1950s for a real estate agency at the bottom of the hill on Aurora Avenue and sang for many years in the choir at St. John's Parish. Both loved to dance and play bridge.

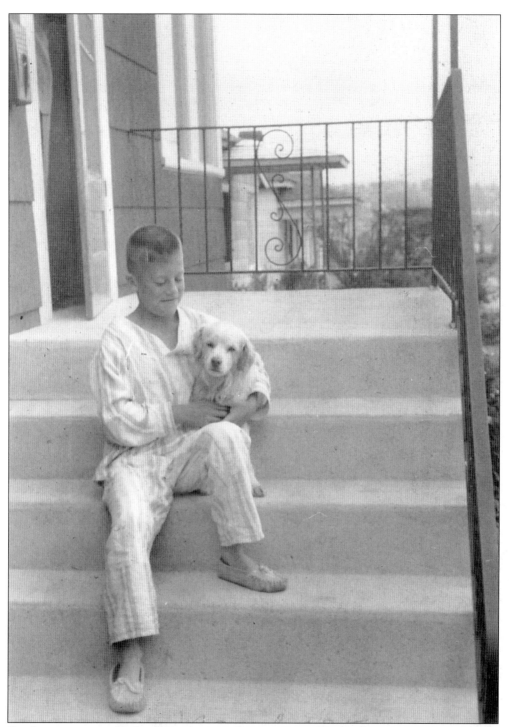

On those same steps, Richard Strophy sits in his pajamas and loafers, hugging a younger Snuppy in March 1954. In addition to his regular work, his father was also a member of St. Vincent de Paul, where he contributed in efforts taking food to those in need as well as in answering crisis hotline calls at night.

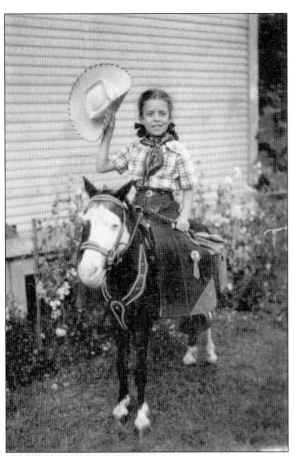

This is Joanne Strophy around 1946 in a posed photograph with a pony. Many people who grew up in Seattle may have an image similar to this one, taken by a traveling photographer who went from one neighborhood to another equipped with Western costumes and a pony.

Richard Strophy (left) is engaged in a boxing pose with Eddie Skaraba, a friend of his from St. John's who also lived in the neighborhood. The dog on the left is Richard's dog Snuppy, and the one on the right is Eddie's dog, name unknown.

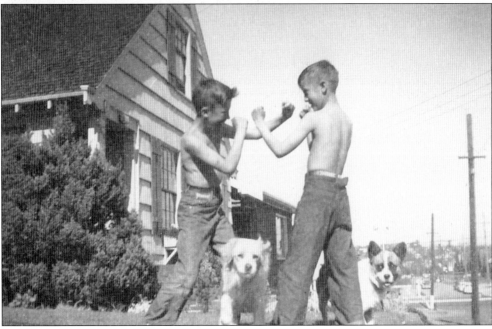

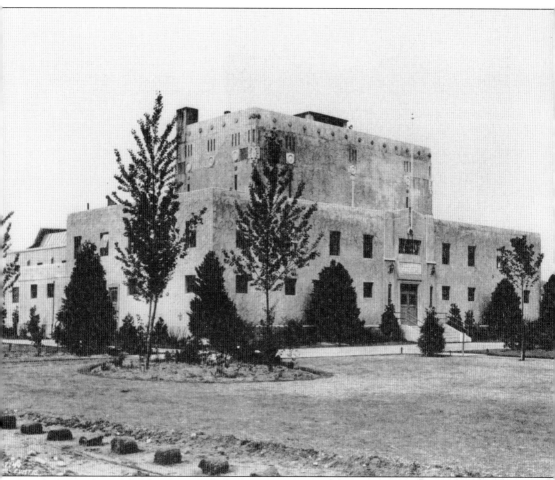

The Green Lake Field House was built in 1929 as one of the first developments immediately following the additional land filled in along the eastern shore. It was intended not only as a companion to the western shore bathhouse for servicing swimmers but also as a multi-purpose recreational facility equipped with social/meeting rooms and a gymnasium. This photograph was taken on June 2, 1931. (Courtesy University of Washington Libraries, Special Collections, A.Curtis58248.)

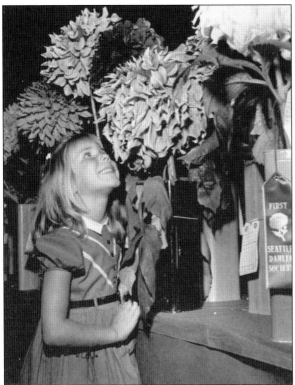

In this 1961 photograph, a beaming young girl gazes at prize-winning dahlias at the Green Lake Field House. (Courtesy *Seattle Post-Intelligencer* Collection, MOHAI, 1986.5.3376.2.)

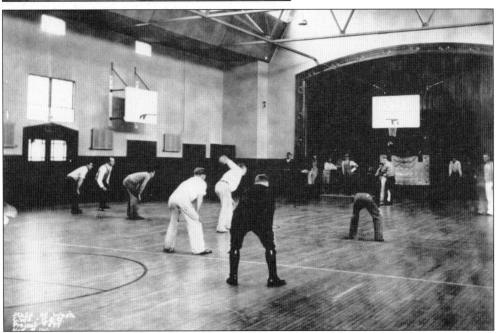

From this angle of a ball game in the multistory gymnasium, taken sometime in the early 1930s, the area that originally served as a stage is visible in the back behind the basketball hoop. The stage section was sacrificed to accommodate the construction of the Evans Swimming Pool, which was added in 1955. (Courtesy University of Washington Libraries, Special Collections, UW11441.)

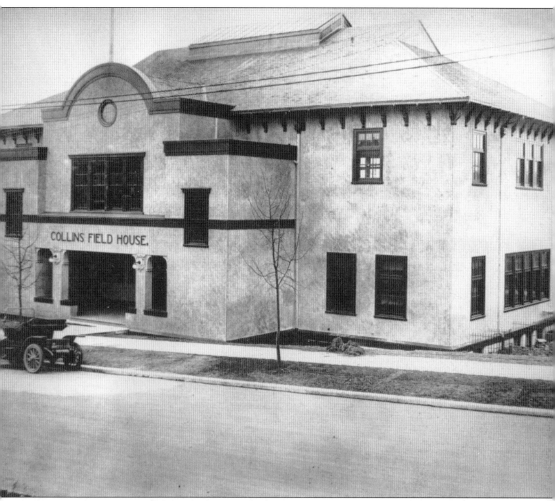

Parked in front of the Collins Field House is Seattle Parks Department director Ben Evans's first automobile. In 1917, around the time that this was taken, Ben Evans (1895–1988) had just started on the path that would provide him with his profound calling within the history of Seattle. After spending just over a year as a playground instructor, he became playground director. Seven years later, he was appointed director of playgrounds and bathing beaches. (Courtesy Seattle Municipal Archives, Item No. 28907.)

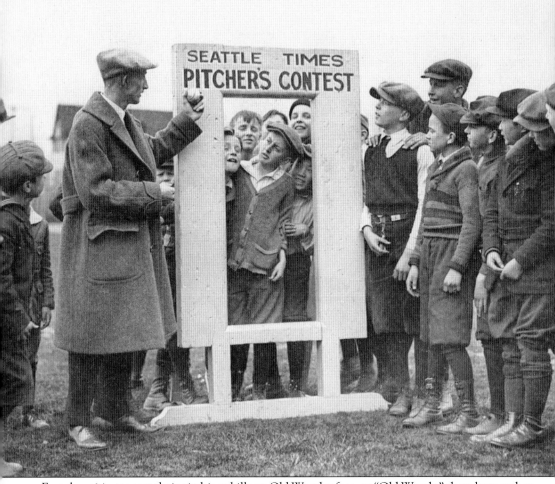

Eagerly waiting to test their pitching skills on Old Woodenface, or "Old Woody," these boys gather around Ben Evans, who devised the competition. In 1922, just two years before this was taken, over 4,500 kids at 23 playgrounds would participate in the contest, which was followed by a parade lasting 20 blocks to the finals at Woodland Park. Old Oswald, or "Old Ossie," involved the same concept, but with a football. (Courtesy Seattle Municipal Archives, Item No. 31108.)

On the wall behind Evans and this unidentified youth is a sign announcing that "Old Woodenface is Coming"— a palpable indication of the eagerness that must have seized the hearts of thousands of young boys in furtive preparation. (Courtesy Seattle Municipal Archives, Item No. 31109.)

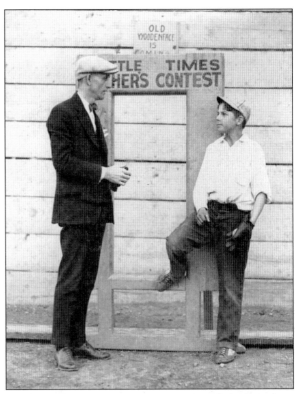

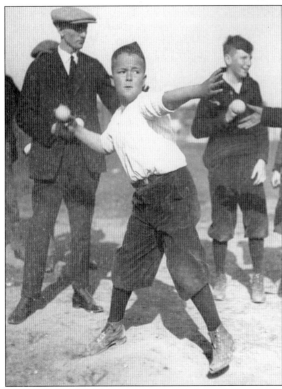

With intense concentration, nine-year-old Douglas Capp takes aim at Old Woody in this April 5, 1923, competition, with Ben Evans supervising in the background. (Courtesy Seattle Municipal Archives, Item No. 31117.)

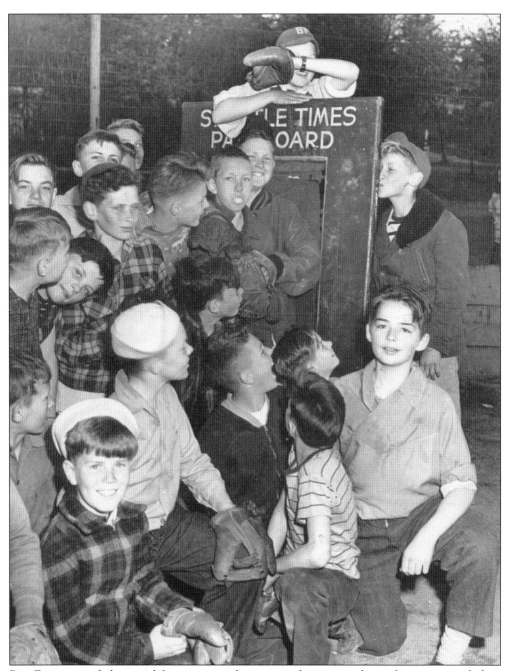

Ben Evans provided counsel for a variety of recreational programs during his career, including the YMCA, the Boy and Girl Scouts, and the Boeing Airplane Company. The boy on the right, giving Old Woody a big kiss, is identified as Tom Weiger. (Courtesy Seattle Municipal Archives, Item No. 31426.)

Luther Evans (1892–1966), the man pictured at center, aided his brother Ben with his various, burgeoning responsibilities for 40 years. Lou began his career in sports and recreation as a lifeguard and high-school athletics coach. After that, he held numerous parks-department titles, such as South Green Lake Beach manager, supervisor of bathing beaches, and assistant director of recreation. (Courtesy Seattle Municipal Archives, Item No. 31395.)

Like his brother, Lou Evans contributed endlessly to the improvement of recreational programs throughout the city. In honor of his youth services, he won the Pop Warner Award in 1961. Even in his retirement, he maintained various important roles, such as vice president of the Seattle Little League. (Courtesy Seattle Municipal Archives, Item No. 31396.)

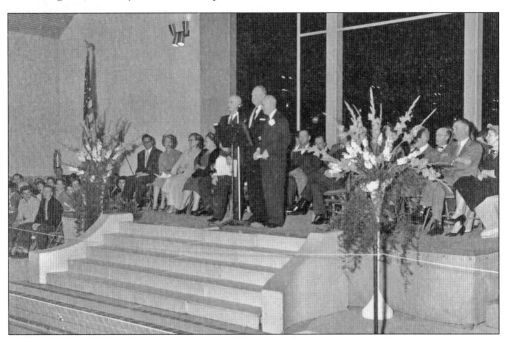

In 1955, the Evans Pool addition to the field house was completed at an approximate cost of $230,000. This photograph was taken at the pool's opening. (Courtesy *Seattle Post-Intelligencer* Collection, MOHAI.)

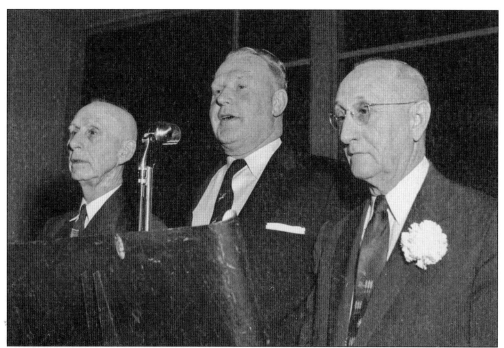

At a lectern at the top of the pool, Ben Evans, Waldo Dahl, and Lou Evans speak at the ceremony. Ben Evans retired five years later in 1960. (Courtesy *Seattle Post-Intelligencer* Collection, MOHAI.)

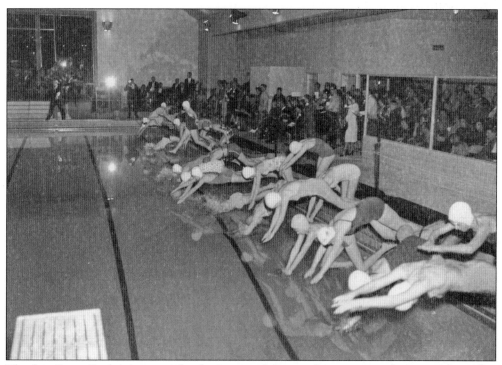

The first Evans Pool swimmers take the inaugural dive in this image as a large crowd watches through the windows. (Courtesy *Seattle Post-Intelligencer* Collection, MOHAI.)

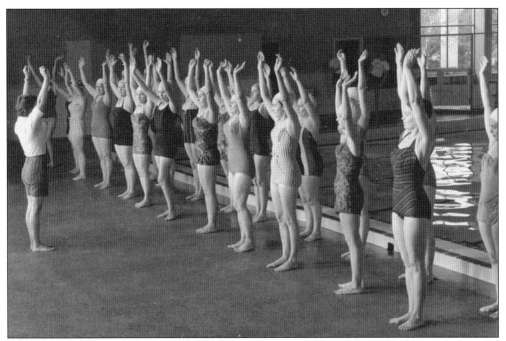

In this photograph, members of a 1964 women's swimming class at Evans Pool line up excitedly to listen to their instructor. (Courtesy *Seattle Post-Intelligencer* Collection, MOHAI.)

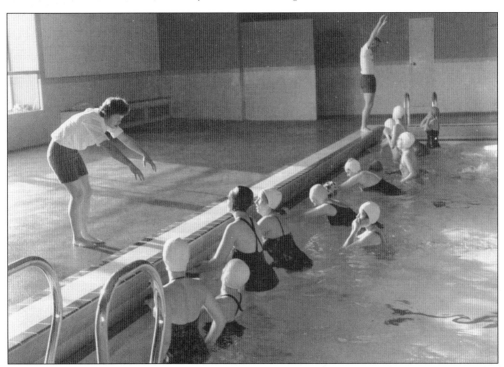

With depths ranging from 3 to 12 feet, Evans Pool is 25 yards long and 42 feet (six lanes) wide. Its amenities include a diving board, changing room, sauna, and slide. (Courtesy *Seattle Post-Intelligencer* Collection, MOHAI.)

Today Evans Pool provides an assortment of aquatic activities for the Green Lake community, including tot, youth, and adult swim classes; competitive training, private lessons, aqua jogging, and water exercise; and family, public, and lap swim hours. (Courtesy *Seattle Post-Intelligencer* Collection, MOHAI.)

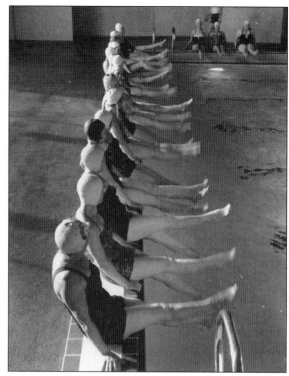

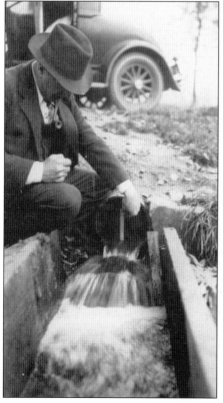

A variety of reoccurring sanitation issues, such as an abundance of algae and pathogens from water fowl refuse, have instigated numerous endeavors to control imbalances. One of the most notable efforts, beginning in 1936, was a multifaceted proposal formulated by sanitation engineer E. French Chase, which included an attempt to purify the water using copper sulfate. In this photograph, dated November 5 of that year, a man kneels beside a water inlet of the lake to add purifying chemicals to the water. (Courtesy Seattle Municipal Archives, Item No. 29194.)

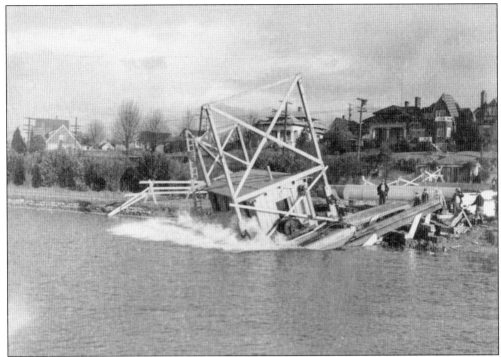

The Works Project Administration (WPA) contributed $234,000 in funding towards cleaning up Green Lake. Along with purifying the water, the project called for dredging the sediments at the bottom in hopes of increasing water flow and drainage. Here workers launch a dredge with a 12-inch pipeline into the lake in 1937. (Courtesy University of Washington Libraries, Special Collections, SEA1077.)

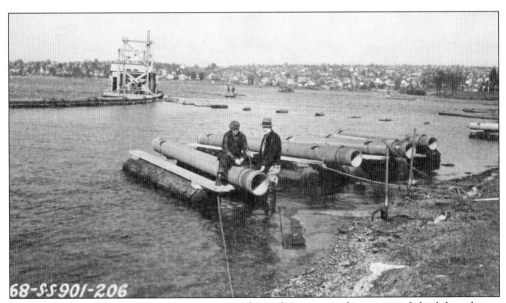

Another part of the plan was to construct a large fountain at the center of the lake, also to encourage water flow. However this scheme never came to pass, due in part to early cost overruns. (Courtesy University of Washington Libraries, Special Collections, SEA1079.)

78

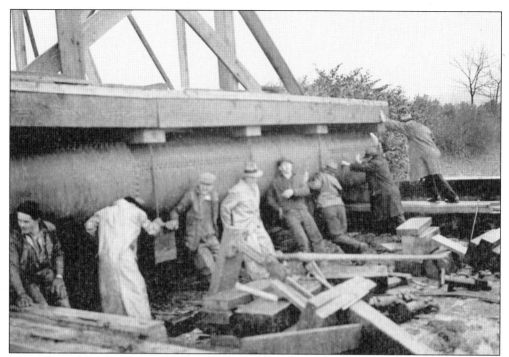

An additional hindrance to the completion of the project came in May 1936, four months after this photograph was taken. The cost of repairs after an explosion on the dredge induced mixed sentiments over further funding from the city council. The dredging project was never completed. (Courtesy Seattle Municipal Archives, Item No. 46418.)

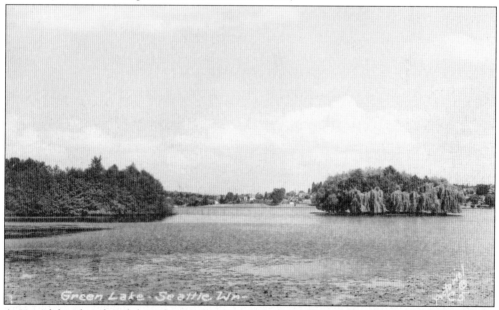

A part of the plan that did reach completion was the formation of a small island wildlife habitat just off the northwest shore of the lake. Duck Island (or the Waldo J. Dahl Game Reserve as it was officially named in 1956) was bestowed with a pair of young swans in 1937 as a gift from Victoria, British Columbia.

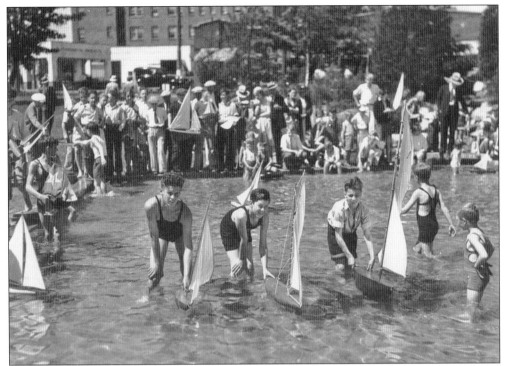

Another WPA-funded addition was the cherished wading pool at the north end of the lake. In this 1934 depiction of youthful play at the site, these boys display their toy sailboats with gleeful pride. (Courtesy *Seattle Post-Intelligencer* Collection, MOHAI, PI24648.)

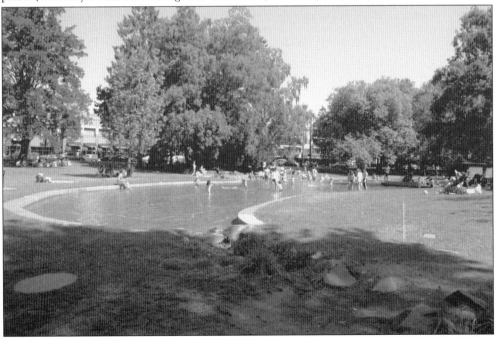

Unchanged since its construction, the wading pool continues to welcome summertime parkgoers with its playful quality as well as by conjuring the spirit of times past.

Three

A LAKE

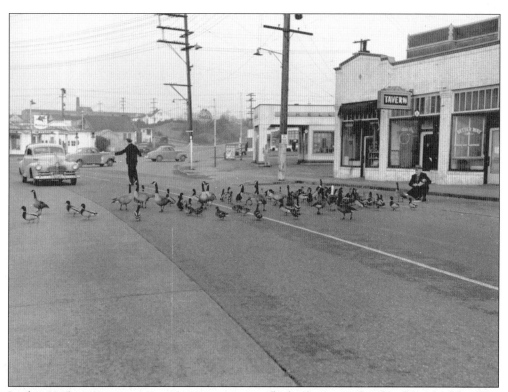

In this 1945 image, two men attempt to protect a flock of geese as they head for the lake. The abundance of wildlife has added to the Green Lake neighborhood's enchantment as well as its troubles. (Courtesy *Seattle Post-Intelligencer* Collection, MOHAI, 1986.5.3662.1.)

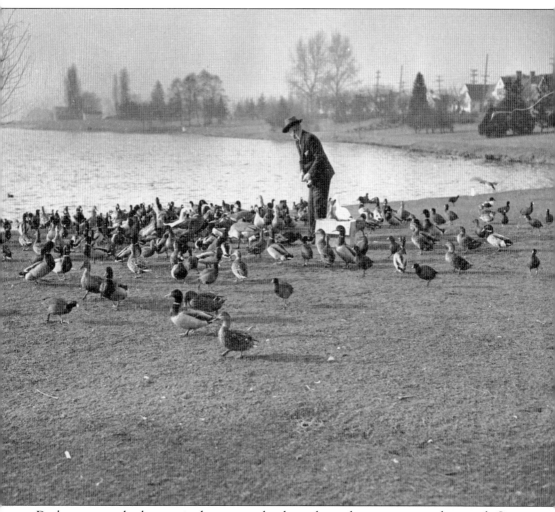

Ducks, geese, turtles, bats, squirrels, raccoons, hawks, eagles, and even cormorants have made Green Lake their home. An enduring overpopulation of waterfowl has instigated numerous concerns over the years, such as bacterial levels, further fertilization of already excessive vegetation, and the restocking of fish. Even in 1945, feeding ducks and geese was probably discouraged. (Courtesy *Seattle Post-Intelligencer* Collection, MOHAI, 1986.5.3662.2.)

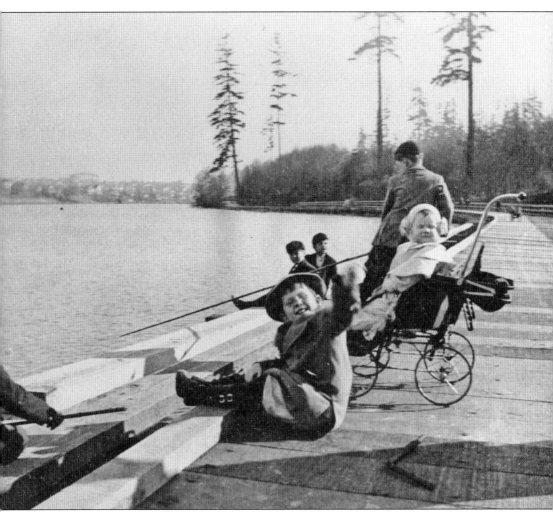

Naturally Green Lake has and will always be associated with the pastime of fishing. The caption for this 1909 photograph identifies the boy who seems to be waving excitedly as George Mack Jr., the son of druggist George C. Mack. His sister, whose married name was A. H. Yngve Hedner, is the infant seated in the buggy. (Courtesy MOHAI, SHS8972.)

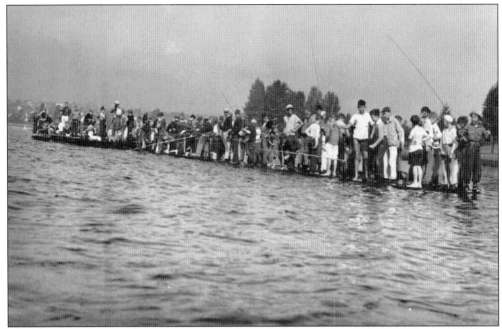

As a member of the park board, Waldo Dahl was also involved in a plan to add a youth fishing pier to a part of the northern side of the lake in 1945 along with a boat-rental facility. In this image, the first fishing derby on east Green Lake is seen in 1930. (Courtesy Seattle Municipal Archives, Item No. 29182.)

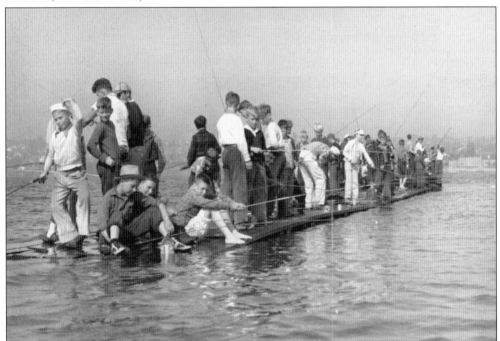

Fish known to have inhabited Green Lake include trout, suckerfish, bass, perch, tiger muskie, carp, and catfish, some of which are still restocked each spring. (Courtesy Seattle Municipal Archives, Item No. 31429.)

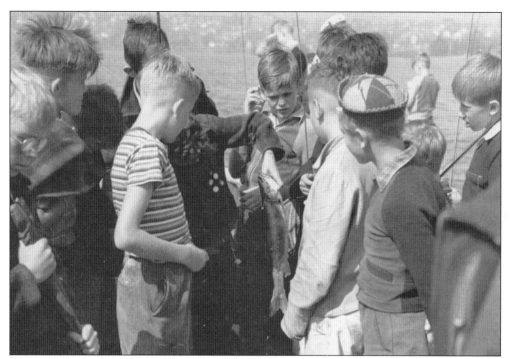

There are currently three fishing piers at Green Lake, located at the foot of Sixty-fifth Avenue Northeast, at the south end of Bathhouse Theater and east of the shell house. (Courtesy Seattle Municipal Archives, Item No. 31430.)

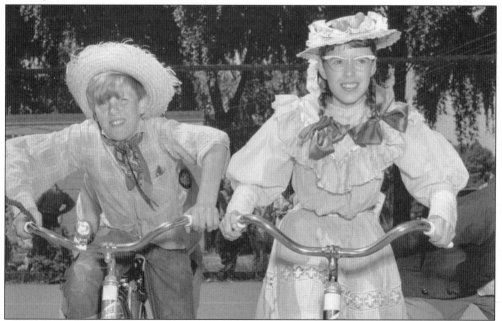

Every year, beginning with Seafair in 1950, a Huckleberry Finn Fishing Contest was held on the north end of Green Lake. First prize for the best Huck Finn and Becky Thatcher look-alikes was a pair of bicycles. Here are the winners in 1959. (Courtesy *Seattle Post-Intelligencer* Collection, MOHAI, 86.5.3192.3.)

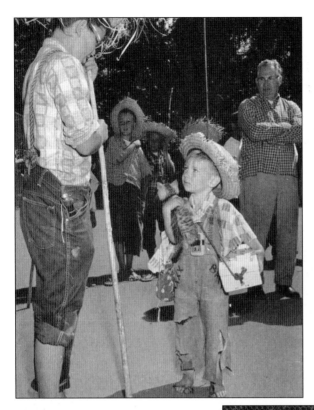

This adorable youngster, also in attendance in 1959, appears to be exceptionally outfitted with every last detail, from the mysterious shoebox that has "open at own risk" written across the top to his indignant upward glance toward the older look-alike talking to him. (Courtesy *Seattle Post-Intelligencer* Collection, MOHAI, 86.5.3192.2 .)

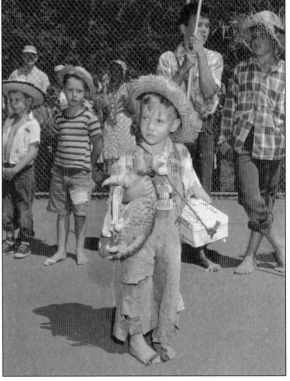

The same boy stands in front of the various Huck Finns lined up, his kitten dangling limply from his protective grip. Additional prizes, such as a complete set of fishing gear, were given out for the biggest fish and the most fish caught. (Courtesy *Seattle Post-Intelligencer* Collection, MOHAI, 86.5.3192.1.)

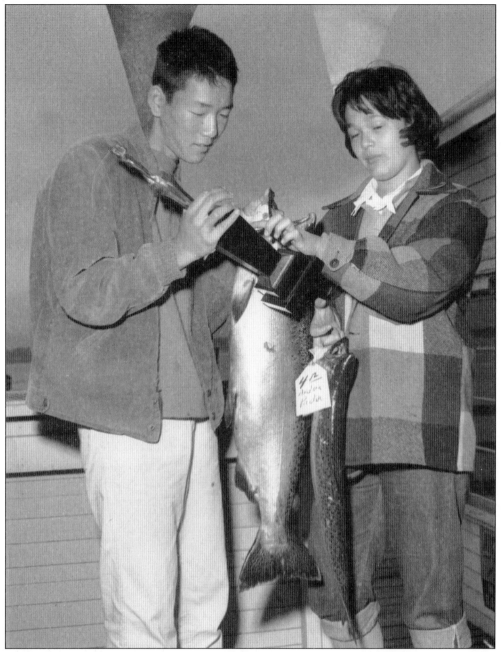

In this photograph, taken August 1961, the first- and second-place Fish Derby winners, Alan Sakamoto and Andrea Padua, are holding up their prize fish. (Courtesy *Seattle Post-Intelligencer* Collection, MOHAI, 86.5.3194.1.)

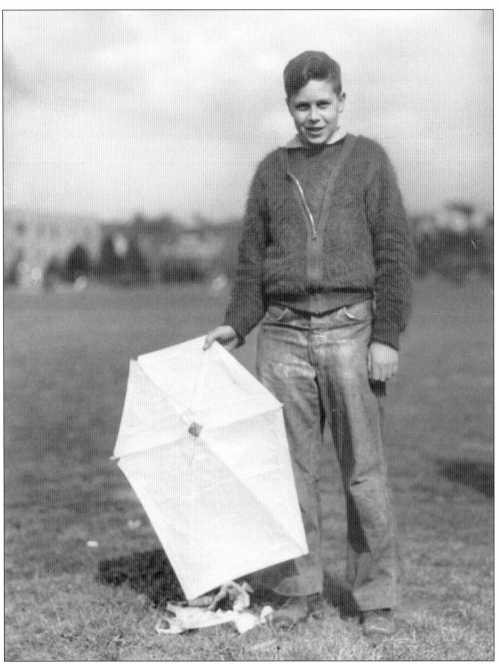

The spirited nature around Green Lake has drawn neighbors together in a variety of friendly competitions and activities for decades. This young boy, identified by the caption as Bruce Benton age 12, is participating in a kite contest at the lake, probably sometime in the 1950s. (Courtesy Seattle Municipal Archives, Item No. 31072.)

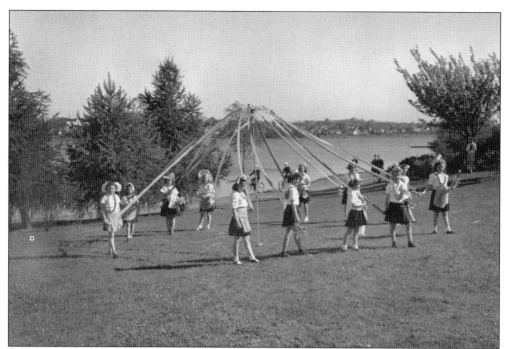

Here a group of young girls skip around a maypole with Green Lake in the background on a clear, mid-summer day in 1944. (Courtesy *Seattle Post-Intelligencer* Collection, MOHAI, PI24660.)

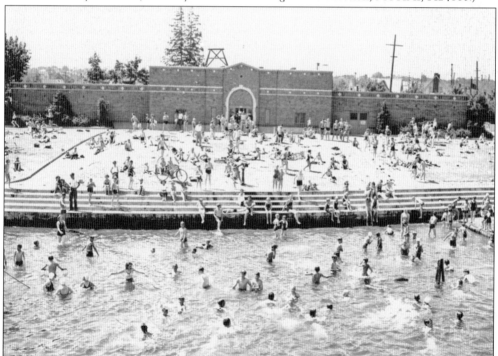

This bathhouse was built from 1927 to 1928 next to an outdoor swimming area with concrete steps leading into the water on the west side of the lake. (Courtesy Seattle Municipal Archives, Item No. 10565.)

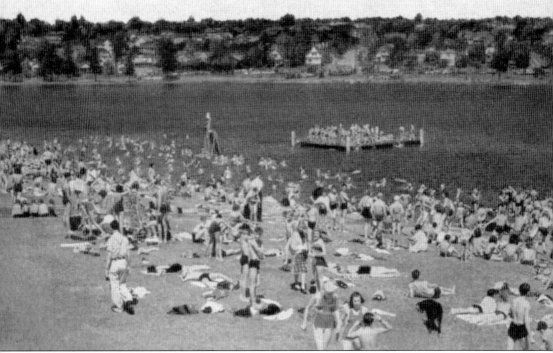

MUNICIPAL BEACH AT GREEN LAKE IN SEATTLE, WASHINGTON

In its first year of construction, the men's and women's changing facilities were built on either end. Following this, the locker rooms and lobby were added in the center. (Courtesy Clinton White.)

As social attitudes towards bathing attire relaxed, the need for changing facilities lessened and, consequently, so did the use of bathhouses. The parks department eventually decided to convert the neglected facilities into various venues for the arts. Seward Park's became an art studio, Madrona Park's became a dance studio, and the Green Lake bathhouse was changed into a theater. This is the interior of the bathhouse when it was still a changing facility. (Courtesy Seattle Municipal Archives, Item No. 10570.)

Beginning the 1970s, the Bathhouse Theater was managed by the city until 1999, when it fell under the direction of Arne Zaslove. (Courtesy Seattle Municipal Archives, Item No. 10572.)

Today, the 165-seat venue is operated by the Seattle Public Theater, with three to four main-stage shows per year and a summer youth program.

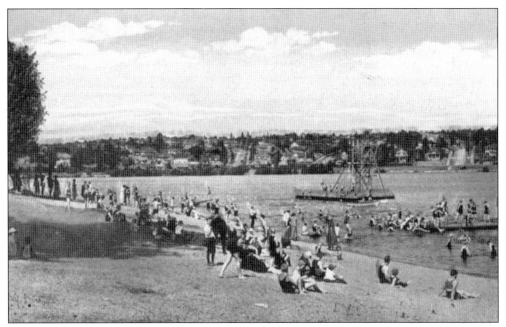

A lifeguard station, with boat, was built next to the bathhouse in 1930 after several drownings in 1929. (Courtesy Clinton White.)

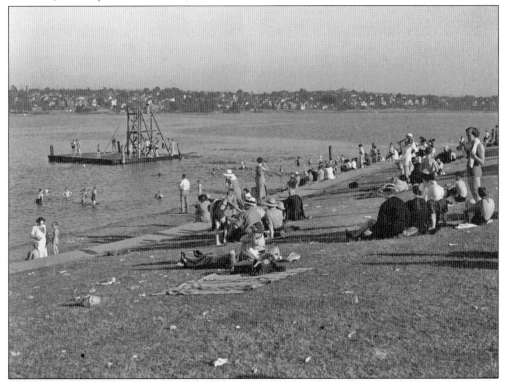

This is a 1937 image after the completion of one effort to clean the lake. The swimming area in front of the bathhouse boasted a float with a wooden diving platform. (Courtesy *Seattle Post-Intelligencer* Collection, MOHAI, PI24649.)

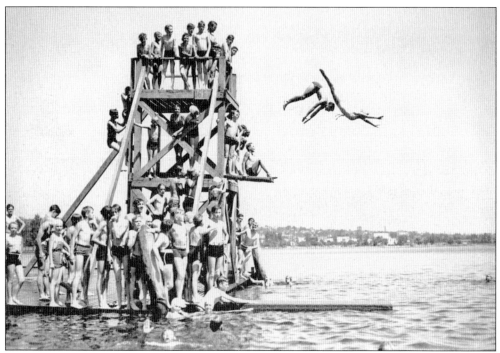

The popularity of the diving platform at the west beach is evident in this 1936 photograph. (Courtesy Seattle Municipal Archives, Item No. 10564.)

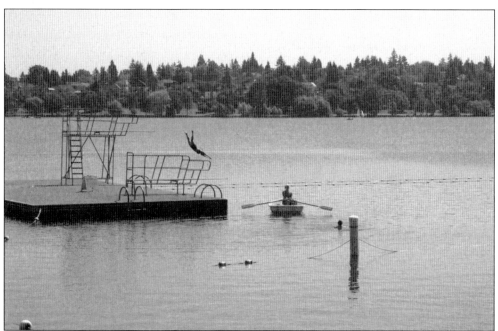

This area still features a diving platform, which sees occasional use, although the wooden version has been replaced by a modern metal type.

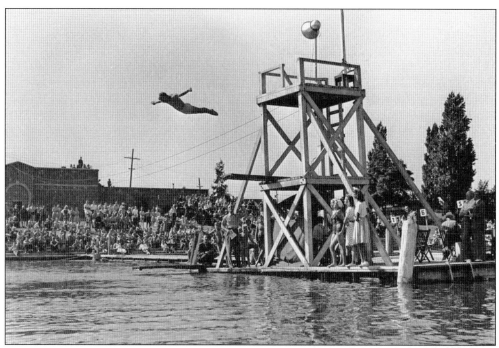

A diving competition during a 1941 Military Day event is depicted here, while an overflowing crowd watches from the bathhouse steps. (Courtesy *Seattle Post-Intelligencer* Collection, MOHAI, PI24653.)

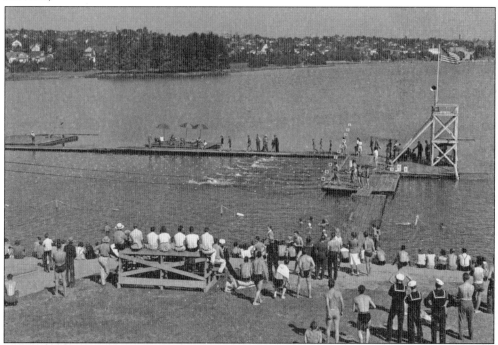

In 1933, Seattle's first annual high-school swim meet was held at Green Lake. This image, also from the 1941 Military Day competitions, was taken during a high-school boy's class race. (Courtesy *Seattle Post-Intelligencer* Collection, MOHAI, PI24652.)

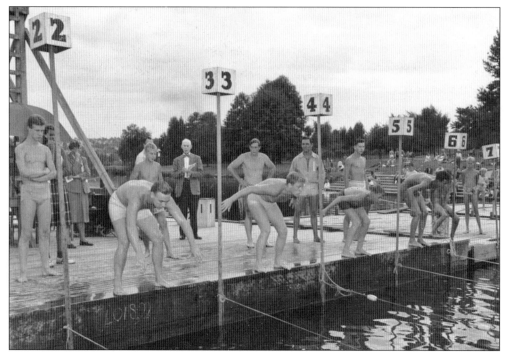

In this 1947 depiction of a high-school boys 200-yard freestyle relay, the starters prepare to take off, while their teammates wait intently for their turns. (Courtesy *Seattle Post-Intelligencer* Collection, MOHAI, PI26987.)

To the puzzlement of at least one young onlooker, a (mostly) all-girl class practices life-saving techniques in this July 1936 picture. (Courtesy Seattle Municipal Archives, Item No. 10664.)

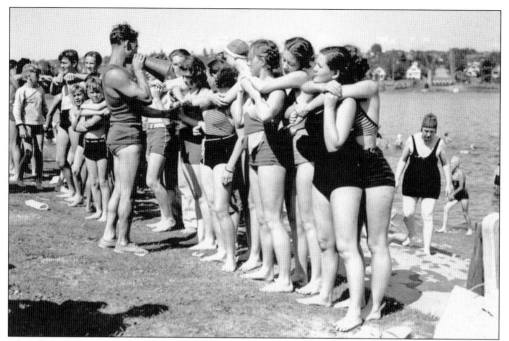

The instructor of the life-saving class delivers advice to his charges as the lesson continues. (Courtesy Seattle Municipal Archives, Item No. 10665.)

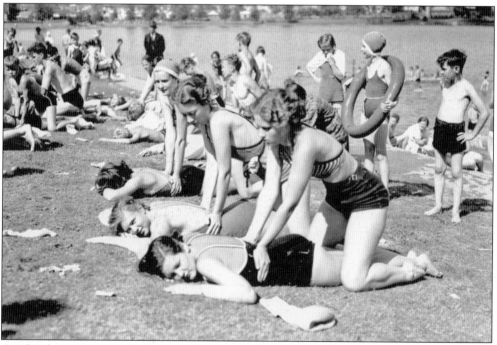

Artificial resuscitation drills are under way in this photograph, attracting the interest of a group of young spectators. Swim and life-saving classes have been a part of Green Lake for generations. (Courtesy Seattle Municipal Archives, Item No. 10669.)

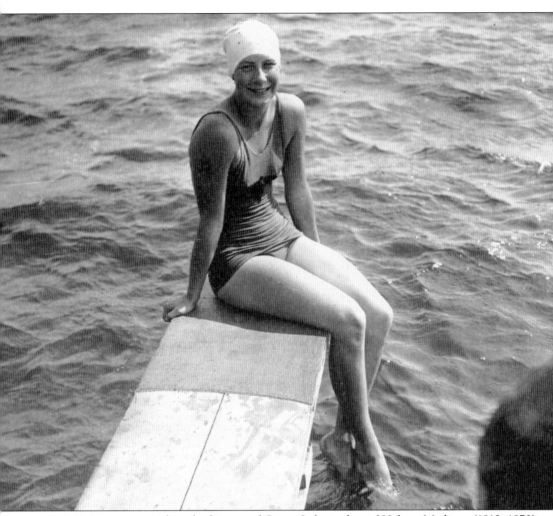

A prominent story within the history of Green Lake is that of Helene Madison (1913–1970), starting at the age of two with her first Seattle Park Department swimming classes on the lake. By her early teens, she was training competitively under coach Ray Daughters as she began breaking international records. This photograph was taken in 1930, probably at Green Lake. (Courtesy *Seattle Post-Intelligencer* Collection, MOHAI, 1986.5G.1764.)

At age 19, Madison won three gold medals in women's freestyle swimming at the 1932 Olympics, held in Los Angeles, California. Upon her return to Seattle, she was welcomed with Seattle's largest ticker-tape parade and honored with the gift of a car. This photograph was taken three years prior to the Olympics. (Courtesy PEMCO Webster and Stevens Collection, MOHAI, 1983.10.12759.2.)

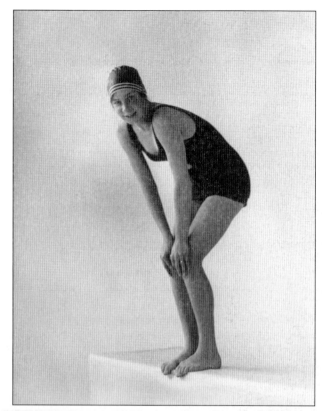

Following her return to the city, Madison made a few attempts at turning her celebrity status into a paying or professional position, including a starring role in a Mack Sennett comedy *The Human Fish*. (Courtesy *Seattle Post-Intelligencer* Collection, MOHAI, 1986.5G.1757.)

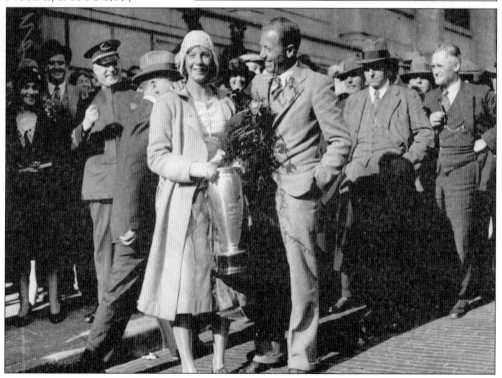

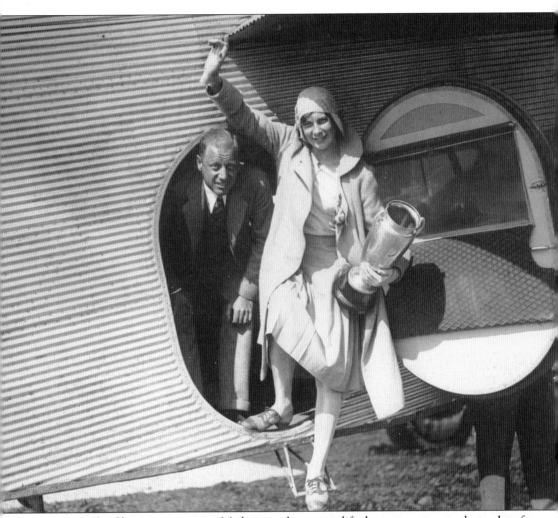

As a result of her transgressions, Madison no longer qualified as an amateur and was therefore not permitted to participate in the 1936 Olympics in Berlin, Germany. She died on November 27, 1970, at her Green Lake apartment. Today both the downtown Washington Athletic Club pool and the 13401 Meridian Avenue N facility are named after her. (Courtesy *Seattle Post-Intelligencer* Collection, MOHAI, 186.5G.1755.)

Opened in April 1948 at an initial cost of roughly $17,000 and purchased by the parks department in 1953, the Pitch N' Putt golf course consists of nine holes on six acres as a par 27. A good short-game course for beginners, it remains a well-liked attraction at the lake to this day. Workers prepare land for the golf course during its construction in this 1947 image. (Courtesy Seattle Municipal Archives, Item No. 29167.)

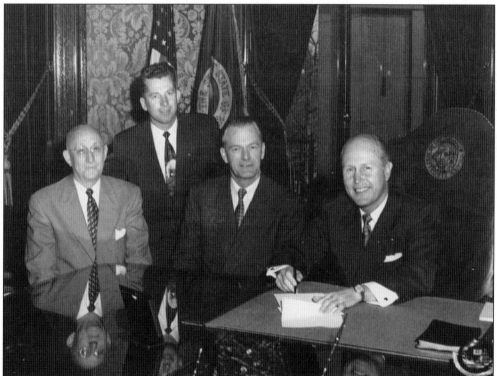

In this portrait, Ben Evans (far left) sits with, from left to right, Robert C. Stephens, Gene Walby, and Gov. Arthur B. Langlie. Langlie (1900–1966) was elected mayor of Seattle in 1938 and then reelected in 1940. He resigned the following year to become governor of Washington. (Courtesy Seattle Municipal Archives, Item No. 31385.)

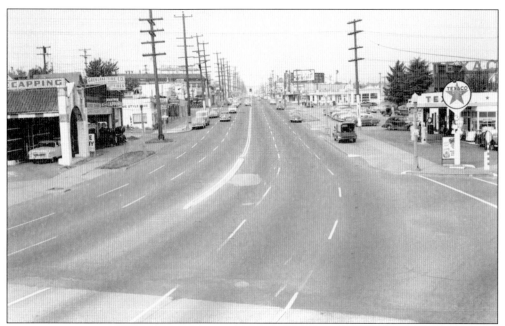

In the 20th century, the construction and widening of Aurora Avenue, as it became the main north-south route through Washington State, had a major effect on the Green Lake and Woodland Park neighborhoods. Residential areas were converted into long stretches of businesses competing to attract highway motorists, thus forcing communities to divide, families to relocate, and residents to seek goods and services outside their usual sphere of local merchants. (Courtesy Seattle Municipal Archives, Item No. 44680.)

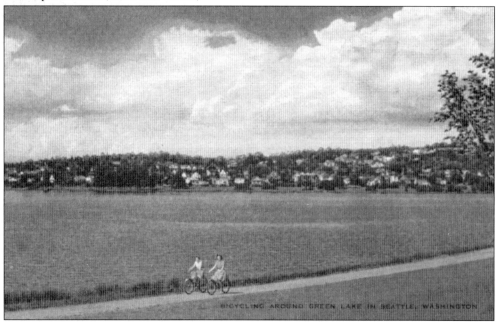

By 1939, around the time that the photograph from which this rendition was produced was taken, cyclists had begun to flourish on the trail around the lake. After about 30 more years of wear, some of the much-treaded pathways would be paved, beginning in 1970. (Courtesy Clinton White.)

Four

AN EVENT

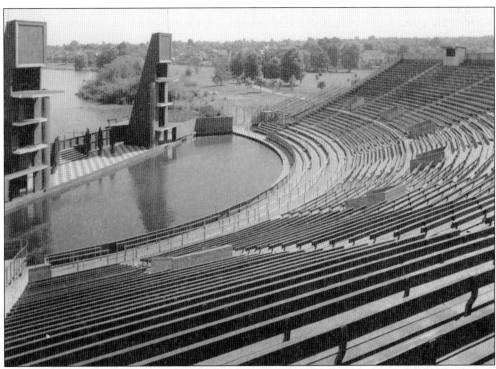

The Aqua Theater, as it is seen here in 1951, was built on the south shore of Green Lake with seven tiers of seating for up to 5,200 people, a stage with two 40-foot diving platforms on either side, and a 180-by-67-foot pool with a maximum depth of 15 feet. Its story begins with the Seattle Salts, a 24-member committee inspired to organize a summer extravaganza with a maritime theme. As their model for creating the ultimate celebration, The Seattle Salts (which would later be called Greater Seattle, Inc.) chose the St. Paul Winter Carnival in Minnesota. (Courtesy University of Washington Libraries, Special Collections, Hupy5185-6.)

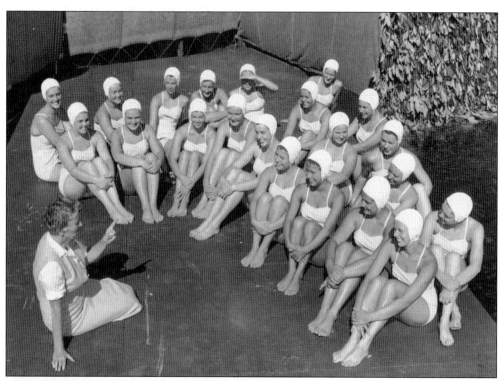

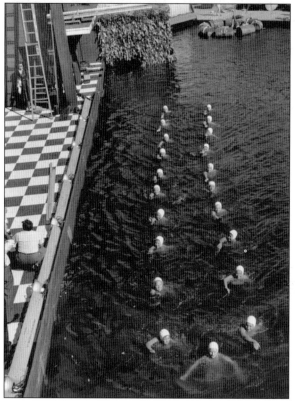

A large part of their vision for the festival hinged on the concept of the Aqua Theater. Designed by George Stoddard and Associates, who also designed the south stands at the University of Washington Husky Stadium, the proposed theater was approved by the Seattle City Council on June 1, 1950. It took Strand and Sons 67 days to build it, costing $247,000. Above, Aqua Theater swimmers are cheerfully gathered for practice. (Courtesy *Seattle Post-Intelligencer* Collection, MOHAI, PI27073.)

Seafair was given its name by the 11-year-old son of Guy Williams, who temporarily headed organizational efforts. On March 15, 2005, the director of the St. Paul Winter Carnival, Walter Van Camp, took over for Williams. This overhead view provides a glimpse of Aqua Theater practice in action. (Courtesy *Seattle Post-Intelligencer* Collection, MOHAI, PI27072.)

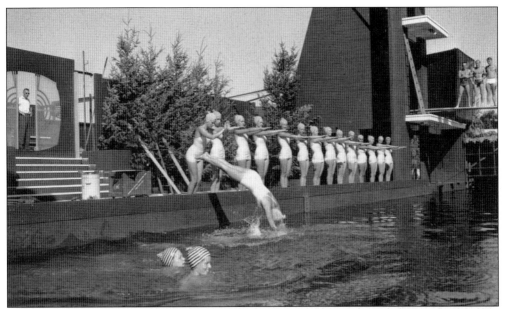

Produced and directed by Al Sheehan, the core performers of the Aqua Follies included 30 female synchronized swimmers (the Aqua Dears), 24 stage dancers (the Aqua Darlings), and the Aqua Divers. Shows began as late as 11:15 p.m., called "Moonlight Matinees." (Courtesy *Seattle Post-Intelligencer* Collection, MOHAI, 1986.5.377.1.)

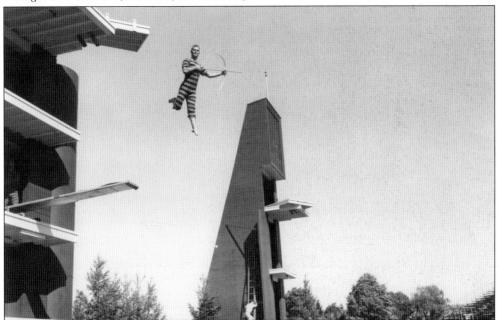

The history of Seafair is rich with an extraordinary variety of events. These activities include, but are certainly not limited to, swim meets, waterskiing competitions, golf and badminton tournaments, boat races, parades, musicals, beauty contests, the world's largest clambake, Scottish Highland games, bicycle races, fishing contests, fireworks, and even a Police Pistol Contest. In this wonderfully timed photograph, an Aqua Diver is captured posing in midair as Cupid with his bow and arrow. (Courtesy *Seattle Post-Intelligencer* Collection, MOHAI, PI27071.)

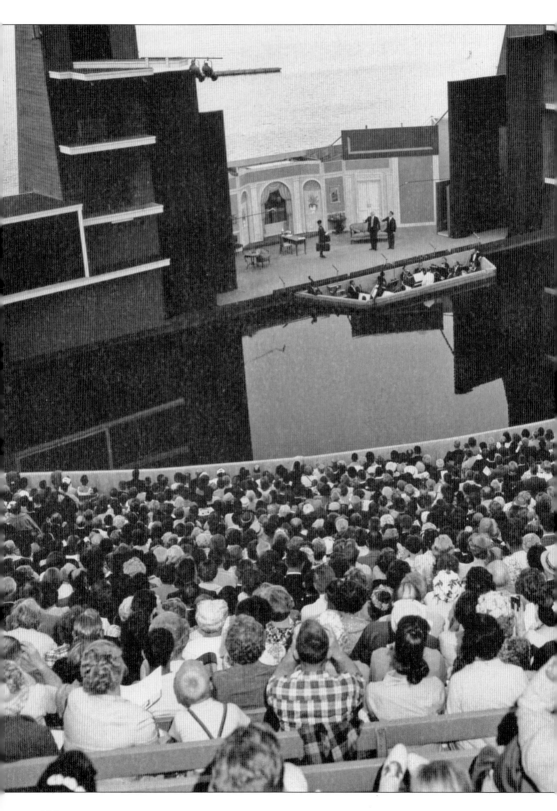

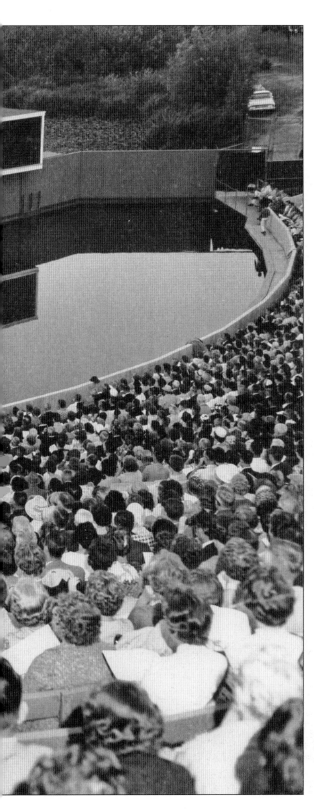

On August 11, 1950, Victor E. Rabel, president of the Star Machinery Company, and Barbara Curtis were crowned the first-ever Seafair royalty. That night, the Aqua Follies opened to a sold-out crowd of 5,200. (Courtesy *Seattle Post-Intelligencer* Collection, MOHAI, 1986.5.12622.1.)

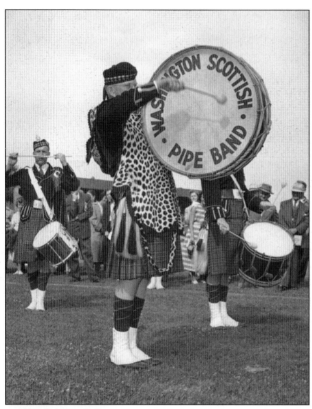

As a part of Seafair, thousands of spectators attended the International Scottish Highland games, where hundreds of participants from the Northwest and Canada came to compete. In this photograph, the Washington Scottish Pipe Band performs outside the Aqua Theater. (Courtesy Seattle Municipal Archives, Item No. 31245.)

Some of the contests at the Scottish Highland Games included tug-of-war, Highland Fling, shot put, caber toss, dancing, and bagpipes. (Courtesy Seattle Municipal Archives, Item No. 31264.)

On the second-to-last day of these festivals, a giant ship burning, involving hundreds of gallons of fuel oil and explosives, took place in Elliott Bay. The vessel sacrificed at the first Seafair was the steamship *Bellingham*, built in 1891. This ritual ended in the 1960s, when they ran out of ships. (Courtesy Seattle Municipal Archives, Item No. 31247.)

By 1960, Aqua Theater attendance justified an expansion that provided almost 400 additional seats. Ticket prices ranged from $2 for the farthest seats, to $3.50 for box seats. (Courtesy *Seattle Post-Intelligencer* Collection, MOHAI, PI27070.)

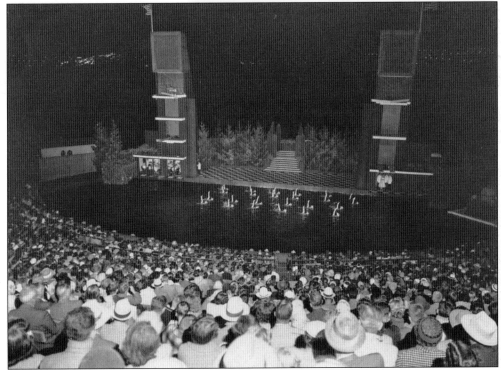

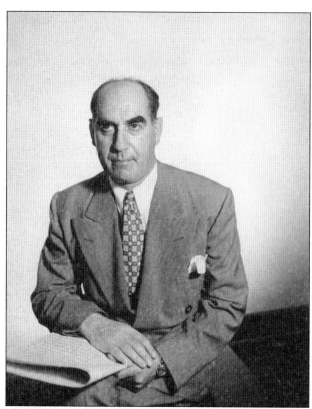

Another eagerly anticipated event that took place at the Aqua Theater was "Music Under the Stars," a series of evening operettas and ballets produced by the Summer Opera Company and conducted by Gustav Stern, pictured here. (Courtesy Seattle Municipal Archives, Item No. 29957.)

This photograph was taken in June 1952 at the KING television studio. The two dancers, Colleen Corkery (left) and Diane Dembo, are demonstrating a dance number from the Cole Porter music show being performed at Music Under the Stars that season. (Courtesy *Seattle Post-Intelligencer* Collection, MOHAI, PI21633.)

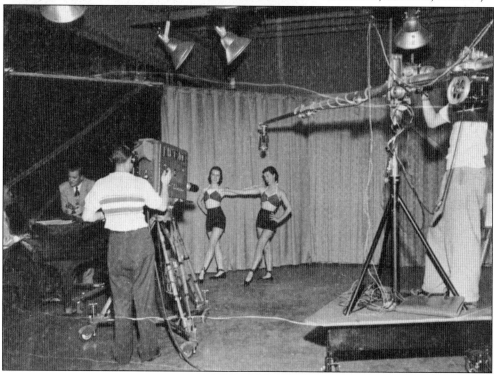

Musical masterpieces must have translated well to this unusual stage setting, since they were extremely well received. A few that played the Aqua Theater consistently were *The King and I*, *South Pacific*, *Silk Stockings*, and *Oklahoma*. Ann Needham, pictured here, worked as a choreographer at the Aqua Theater. (Courtesy Seattle Municipal Archives, Item No. 31263.)

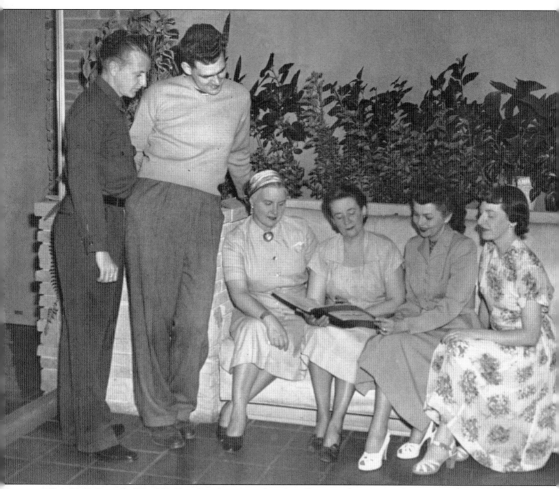

The 1962 Seattle World's Fair has been credited with contributing to the Aqua Theater's biggest moment as well as its decline. Beginning with a three-day jazz festival in June, the theater hosted five different productions that summer, including a well-remembered set of five performances by Bob Hope and dancer Juliet Prowse. Pictured from left to right in this photograph taken at the Aqua Theater, John Wright, Charles Trombley, Gene Sundsten, Marjorie Myers, Lorene Nicolai, and Civilla Allyn are looking over what is probably a script. (Courtesy Seattle Municipal Archives, Item No. 31270.)

After Bob Hope's first performance sold out, coordinators seated 140 additional fans in four-person rowboats in the pool area between the stage and the stadium. In the Aqua Theater performance pictured here, Beth Hawkins sings with an unidentified actor. (Courtesy Seattle Municipal Archives, Item No. 31243.)

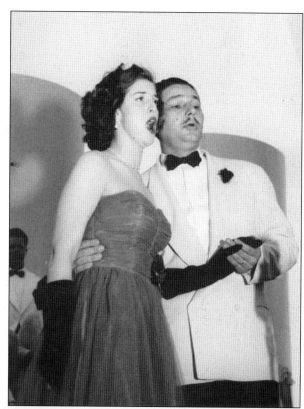

Following the Bob Hope performances, the 1962 Seafair was capped off by a 21-day run at the Aqua Theater, featuring *Annie Get Your Gun* with Gizele MacKenzie and *Music Man* with Bert Parks and Barbara Williams, who had previously performed the musical on Broadway. This portrait features actress Alleen Aune, a woman who performed numerous times at Aqua Theater. (Courtesy Seattle Municipal Archives, Item No. 31244.)

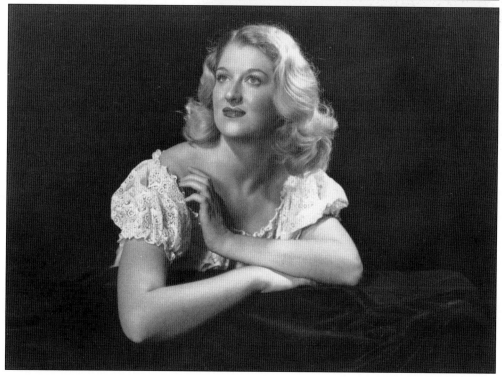

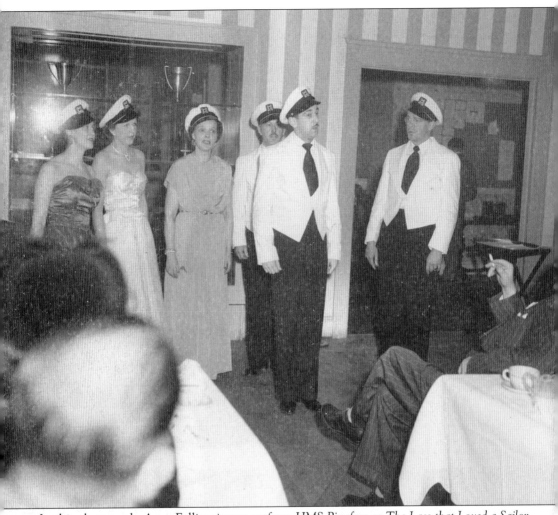

In this photograph, Aqua Follies singers perform HMS *Pinafore* or *The Lass that Loved a Sailor*, the comic two-act opera by W. S. Gilbert and Arthur Sullivan. (Courtesy Seattle Municipal Archives, Item No. 31265.)

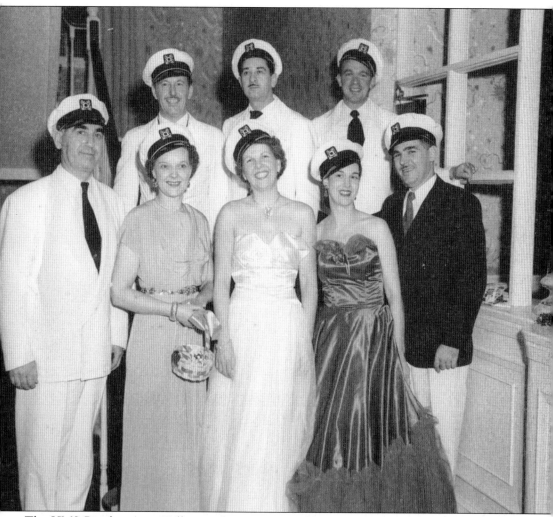

The *HMS Pinafore* Aqua Follies performers pictured here are, from left to right, (first row) Gus Stern, Wilma Snellenberg, Jean Gray, Jean Herbert, Tom Herbert; (second row) Charles Sherwood, Wally Snellenberg, Dave Herald. (Courtesy Seattle Municipal Archives, Item No. 31266.)

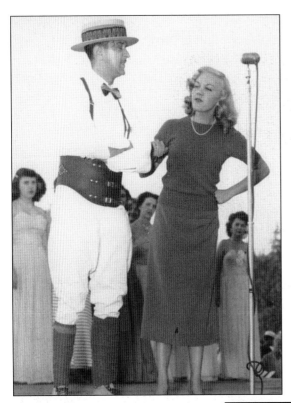

After the World's Fair, the newly constructed Seattle Center continued to draw crowds, detracting from the previous popularity of the Aqua Theater. Its indoor event seating and accommodations protected visitors from the elements, which might otherwise spoil the entertainment at an outdoor venue. The actors pictured here are Walter Snellenberg (left) and Alleen Aune (right). (Courtesy Seattle Municipal Archives, Item No. 31260.)

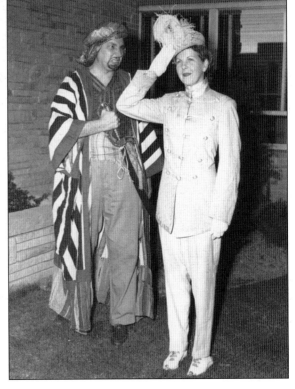

After the Aqua Follies ended in 1964, the theater crept out of use, with the exception of sporadic, local productions. One of the last events held at the Aqua Theater was a Grateful Dead concert in 1969. This photograph, taken in 1950, shows Aqua Theater actors Robert Heyworth (left) and Jean Gray (right) in costume for *The Desert Song.* (Courtesy Seattle Municipal Archives, Item No. 31252.)

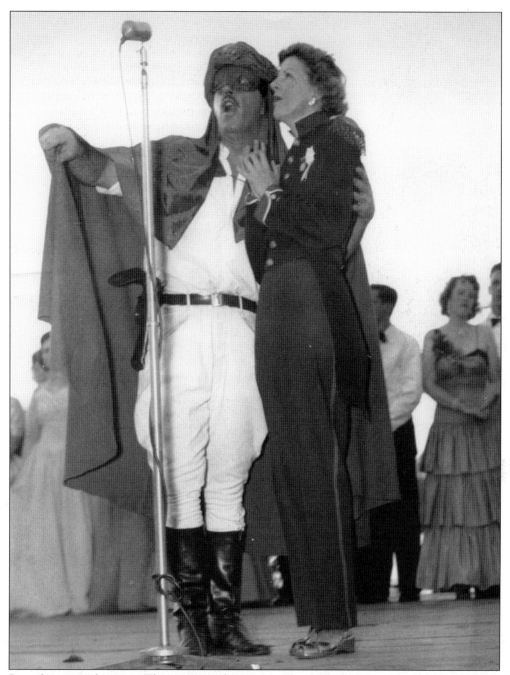

Piece by piece, the Aqua Theater was taken apart. The diving towers went first in 1970 as a provision from a Forward Thrust Bond Resolution. Next to go were the seating and four of the original sections. Performing in this image are Charles Sherwood (left) and Jean Gray (right). (Courtesy Seattle Municipal Archives, Item No. 31258.)

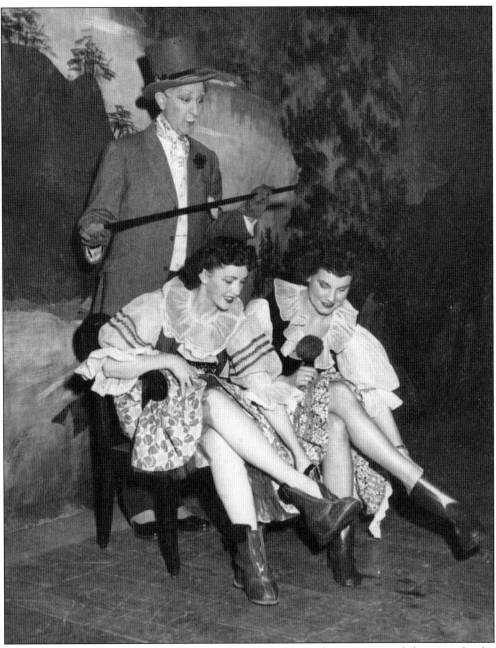

After the Aqua Theater was partially demolished, the parks department used the space for the new shell house (Green Lake Small Craft Center) to further accommodate canoeing, rowing, and sailing activities. The original, smaller shell house was badly damaged in an earthquake in 1965. Here Walter Snellenberg poses with two other unidentified performers. (Courtesy Seattle Municipal Archives, Item No. 31262.)

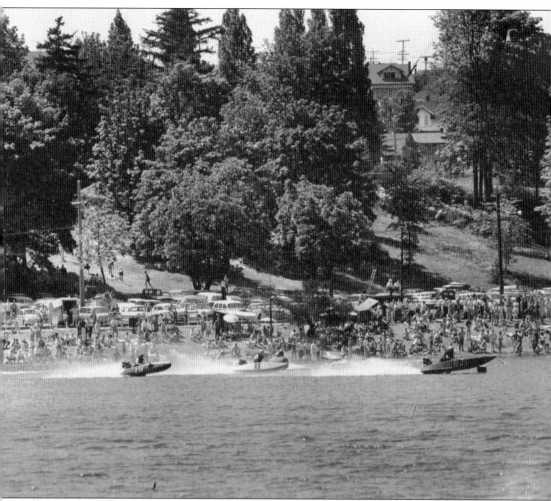

Green Lake has been home to many other notable Seafair traditions, one of which is the Milk Carton Derby, which began in 1972 and continues on as the opening event to this day. Another popular sporting activity was the limited hydroplane races. In this image, a crowd waits in front of parked cars with ladders, umbrellas, and tents to watch the races on Green Lake in 1962. (Courtesy Bob Miller Collection, MOHAI.)

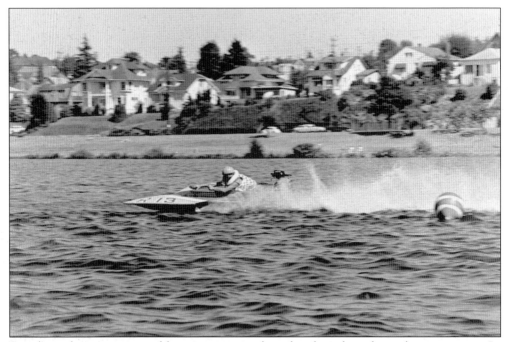

For three days, racers would compete in outboard, inboard, and runabout contests. In 1975, the Heidelberg Inboard World Championships were held at Green Lake. Hydroplane racing on Green Lake was a part of the Seafair festival through 1976. (Courtesy Bob Miller Collection, MOHAI.)

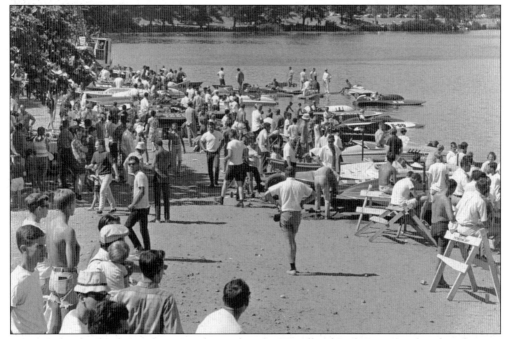

In 1984, the death of an infant snow leopard at the Woodland Park Zoo out of neglect from its mother was attributed to the noise of the hydroplane races, which led to a permanent ban of the activity on Green Lake. (Courtesy Bob Miller Collection, MOHAI.)

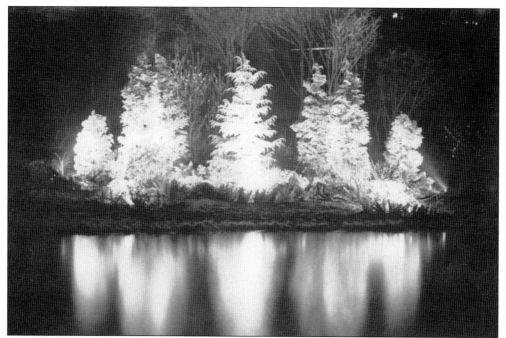

Here is a spectacular Christmas tree lighting reflecting off of Green Lake in 1941. (Courtesy Seattle Municipal Archives, Item No. 18803.)

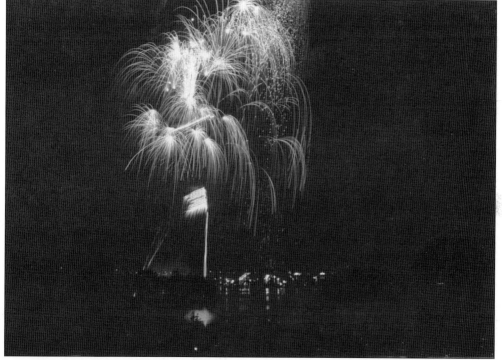

Fireworks shows were held at Green Lake, as perhaps one the most popular events, up until 1980, when they were moved to Lake Union and Elliott Bay. (Courtesy *Seattle Post-Intelligencer* Collection, MOHAI, PI23315.)

Today the 323.7-acre park is still a thriving spot for countless recreations and activities, including windsurfing, tennis, and basketball, as well as canoe, rowboat, and paddleboat rentals.

Traffic control has become a problem on the Lake's 2.8-mile paved path with elaborate rules regarding right-of-way for the joggers, walkers, skaters, and bike riders. A separate cinder jogging trail circles the outer perimeter of the park, running 3.2 miles in length.

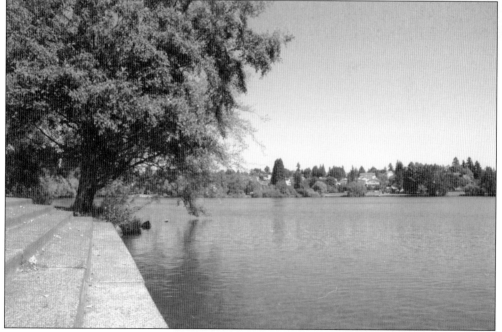

Green Lake has become home to many of Seattle's signature events over the years. The Bite of Seattle had its beginnings on the fields on the north shore. A peace celebration on August 6 commemorating the Hiroshima bombing takes place every year, with floating luminarias launched from the shore beside the Bathhouse Theater.

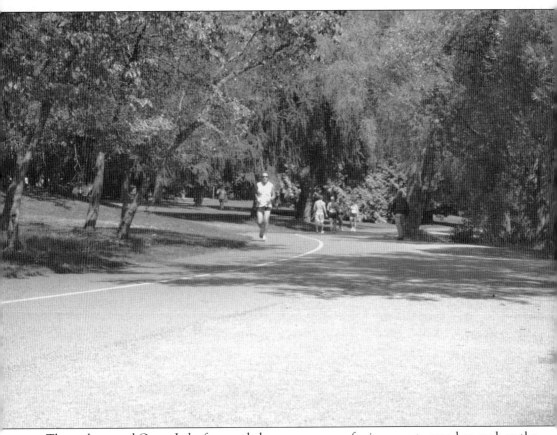

The path around Green Lake frequently becomes a venue for impromptu marches, such as the March 2003 antiwar candlelight demonstration around the lake.

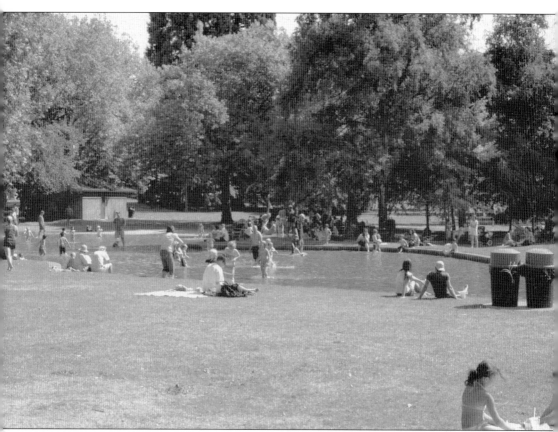

Although much development has occurred around Green Lake, the area is still mostly residential in character, with some of Seattle's nicest homes lining the lake's roadsides. Careful maintenance and landscaping of the grounds of the park, along with the growth of the trees over the years, has resulted in a distinctly lush, pristine appearance.

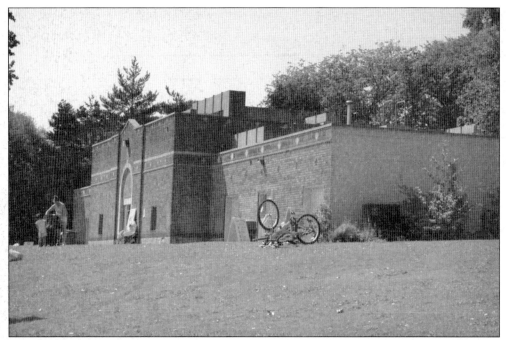

Ideas for new events are still capturing the hearts of motivated lake-lovers. The second annual Green Lake Open Water Swim took place on June 25, 2006, where a large number of participants swam the half-mile together from the east shore to the west.

A Pro Parks project scheduled for construction in the summer of 2007 is designed to add a shade garden and seating plaza around the Green Lake Community Center.

Seattle's love affair with Green Lake guarantees that problems resulting from overuse or crowding will be met by a concerned citizenry dedicated to preserving the lake's ethereal beauty. As one of the nation's most heavily utilized urban parks, Green Lake is sure to continue providing tranquility for the individual as well as inspiration for many traditions to come.

Across America, People are Discovering Something Wonderful. Their Heritage.

Arcadia Publishing is the leading local history publisher in the United States. With more than 3,000 titles in print and hundreds of new titles released every year, Arcadia has extensive specialized experience chronicling the history of communities and celebrating America's hidden stories, bringing to life the people, places, and events from the past. To discover the history of other communities across the nation, please visit:

www.arcadiapublishing.com

Customized search tools allow you to find regional history books about the town where you grew up, the cities where your friends and family live, the town where your parents met, or even that retirement spot you've been dreaming about.